Keys to Painting
Fruit & Flowers

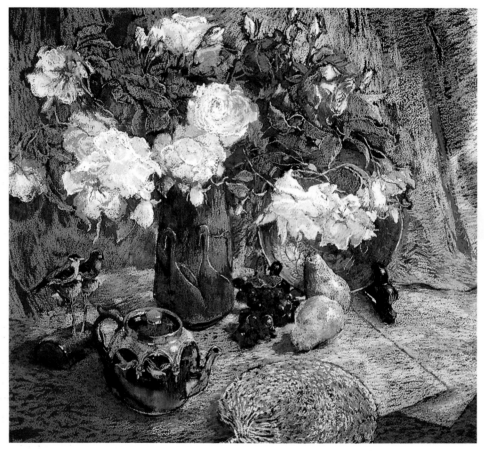

ANITA WOLFF
Spirit of April
Pastel, 30″×32″ (76cm×81cm)

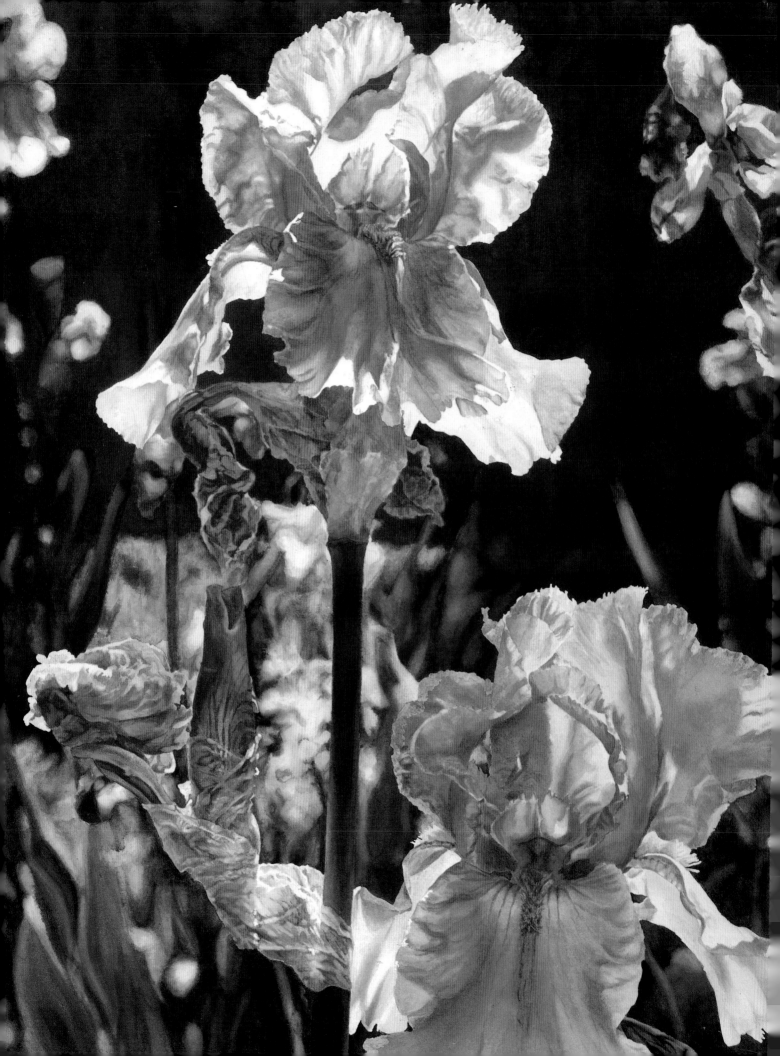

Keys to Painting
Fruit & Flowers

EDITED BY RACHEL RUBIN WOLF

NORTH LIGHT BOOKS
CINCINNATI, OHIO
www.nlbooks.com

The material in this compilation appear in the following previously published North Light Books (the initial page numbers given refer to pages in the original work; page numbers in parentheses refer to pages in this book).

Greene, Gary. *Creating Textures in Colored Pencil* © 1996. Pages 16 (127), 38-39 (50-51), 43 (56), 44-46 (52-53), 48-49 (54-55), 50 (58), 51 (59), 52-55 (60-63), 56 (57).

Katchen, Carole. *Creative Painting With Pastels* © 1990. Pages 4 (83), 22 (84), 67 (81), 108-110 (89-91), 114-117 (86-88), 117 (85), back cover (1).

Macpherson, Kevin D. *Fill Your Oil Paintings With Light & Color* © 1997. Pages 78-81 (92-95), 83 (6), 86 (126).

Heim, Dawn McLeod. *Step-by-Step Guide to Painting Realistic Watercolors* © 1997. Pages 48-55 (38-45), 76-83 (30-37).

Nice, Claudia. *Creating Textures in Pen & Ink With Watercolor* © 1995. Pages 102-103 (46-47).

Pech, Arleta. *Painting Fresh Florals in Watercolor* © 1998. Pages 20 (22), 44-51 (22-29), 56-57 (10-11), 58 (13), 62 (12), 64 (14), 66 (15), 90-93 (18-21).

Simandle, Marilyn and Lehrman, Lewis Barrett. *Capturing Light in Watercolor* © 1997. Pages 16-17 (110-111), 68 (127), 94-101 (118-125), 104-105 (16-17), 108-113 (112-117).

Strisik, Paul. *Capturing Light in Oils* © 1995. Pages 90-91 (96-97).

Wagner, Judi and Van Hasselt, Tony. *Painting With the White of Your Paper* © 1994. Pages 78-79 (48-49).

Wolf, Rachel Rubin. *The Acrylic Painter's Book of Styles & Techniques* © 1997. Pages 46-57 (64-75), 70-73 (76-79).

Wolf, Rachel Rubin. *Painting the Many Moods of Light* © 1999. Pages 57 (5), 62-67 (98-103), 132-137 (104-109).

Wolf, Rachel Rubin. *Splash 4: The Splendor of Light* © 1996. Pages 45 (cover), 127 (2), 133 (8).

Woolwich, Madlyn-Ann C. *Pastel Interpretations* © 1993. Pages 66 (80), 76 (1), 77 (81), 95 (82), 125 (85).

opposite title page
NEDRA TORNAY
Two Violet Irises
42" × 30" (107cm × 76cm)

Keys to Painting: Fruit & Flowers. Copyright © 2000 by North Light Books. Manufactured in China. All rights reserved. No part of this book may be reproduced in any form or by any electronic or mechanical means including information storage and retrieval systems without permission in writing from the publisher, except by a reviewer, who may quote brief passages in a review. Published by North Light Books, an imprint of F&W Publications, Inc., 1507 Dana Avenue, Cincinnati, Ohio 45207. (800) 289-0963. First edition.

Other fine North Light Books are available from your local bookstore, art supply store or direct from the publisher.

04 03 02 01 00 5 4 3 2 1

Library of Congress Cataloging-in-Publication Data

Keys to painting: fruit & flowers.—1st ed.
　　p.　cm.
Edited by Rachel Rubin Wolf
Includes index.
ISBN 1-58180-003-7 (pbk.: alk.paper)
　　1. Fruit in art. 2. Flowers in art. 3. Painting—Technique. 4. Drawing—Technique.
　　I. Title: Fruit & flowers. II. Title: Fruit and flowers. III. Rubin Wolf, Rachel.
ND1400.K48　2000
751.4—dc21
　　　　　　　　　　　　　　　　　　　　　　99-055195
　　　　　　　　　　　　　　　　　　　　　　CIP

Editors: Rachel Rubin Wolf and Amy J. Wolgemuth
Interior production artist: Kathy Gardner
Production coordinator: Emily Gross

ACKNOWLEDGMENTS

The people who deserve special thanks, and without whom this book would not
have been possible, are the artists and authors whose work appears in this book.

Lewis Barrett Lehrman

Barbara Buer

Howard Carr

Mary DeLoyht-Arendt

Elsie Dinsmore Popkin

Gary Greene

William Hook

Melanie Lacki

Jane Lund

Kevin D. Macpherson

Dawn McLeod Heim

Claudia Nice

Arleta Pech

Judy Pelt

Ann Pember

William Persa

Richard Pionk

Marilyn Simandle

Teresa Starkweather

Paul Strisik

Nedra Tornay

Tony Van Hasselt

Judi Wagner

Anita Wolff

Madylyn-Ann C. Woolwich

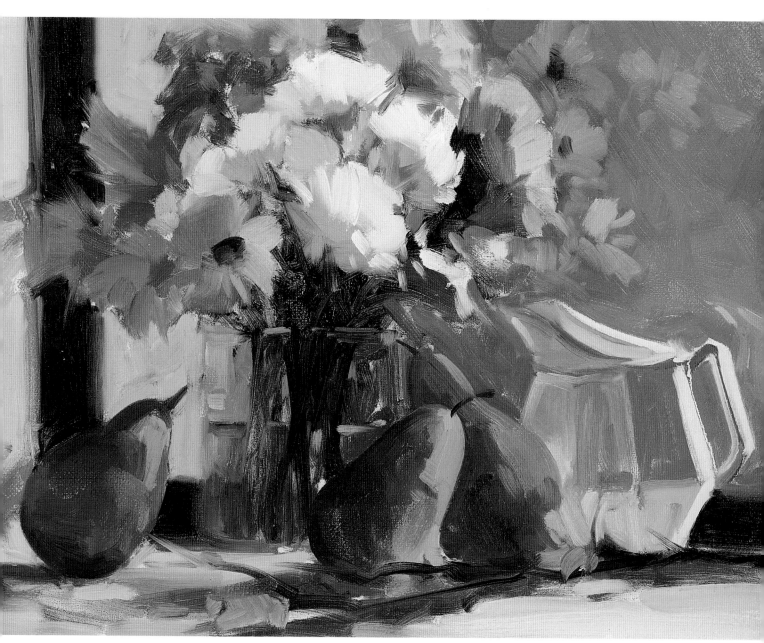

HOWARD CARR
Three Pears
Oils, 16"×20" (41cm×51cm)

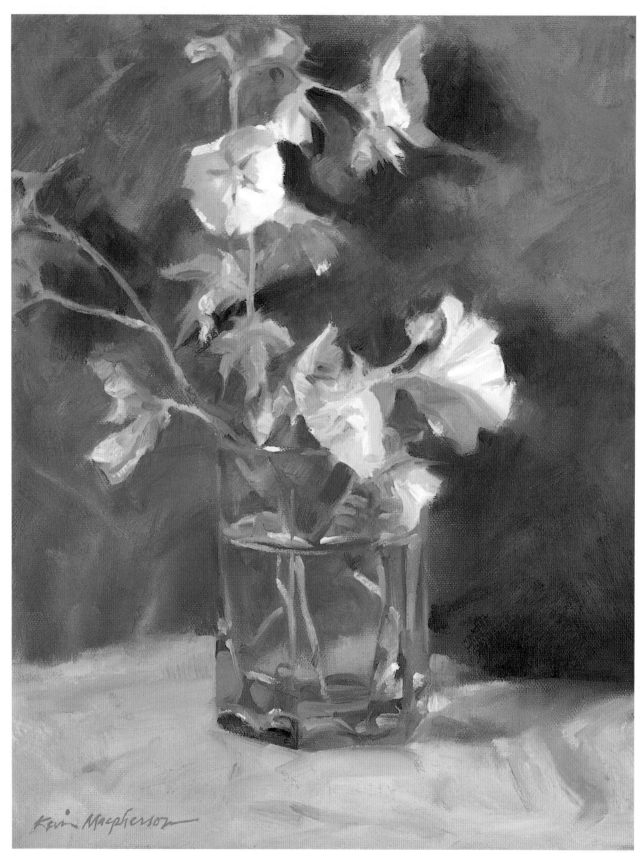

KEVIN D. MACPHERSON
Mountain Hollyhocks
Oils, 14″×11″ (36cm×28cm)

TABLE OF CONTENTS

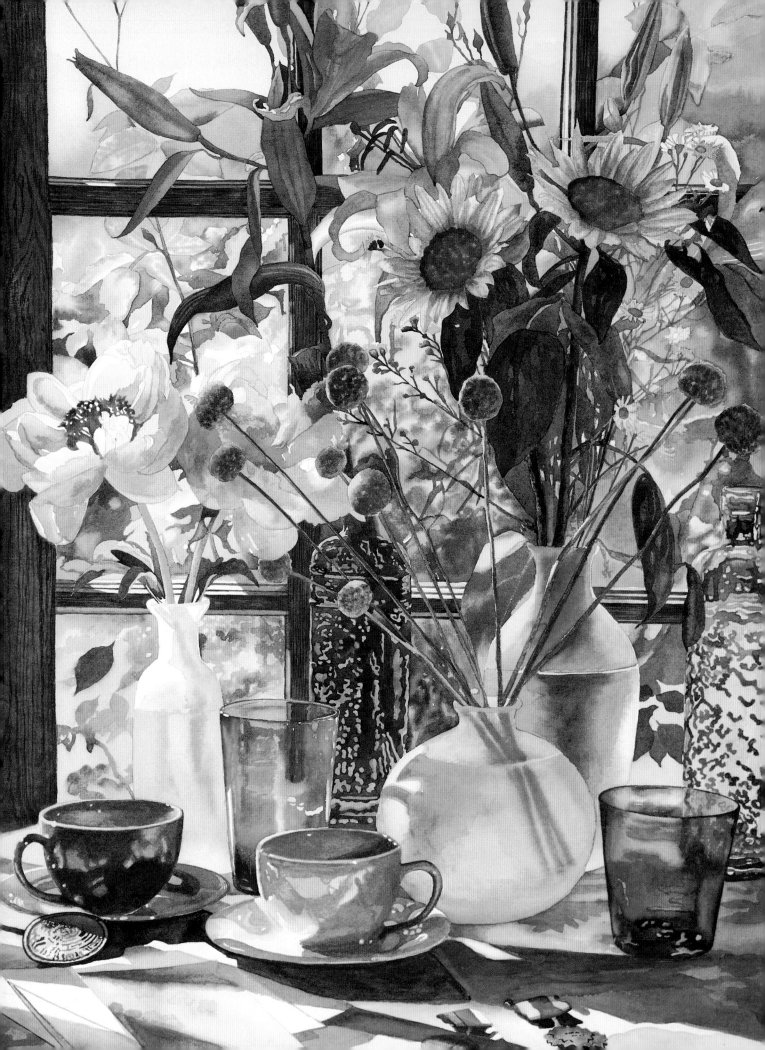

INTRODUCTION

Picture in your mind's eye, if you will, an open-air market. Perhaps a flea market you recently visited on a lazy Sunday afternoon, a village square full of vendors that you strolled through while traveling abroad, or a roadside stand you passed on a winding country road, fruit-filled orchards in the fields behind.

What caught your eye? Was it the brilliant colors of freshly cut flowers? The deep, velvety reds of wild roses? Or was it the delicate pinks and soft yellows of tulips, buds still tightly closed? Or maybe it was the endless rows of produce; stand after stand of fruits and vegetables in boxes, baskets and worn paper bags. The purple and red plums or grapes carefully arranged. Fresh picked berries ready for pies, jams or eating by the handful, not to mention the great abundance of vegetables in all shapes and colors.

After you later spilled your lucky finds on your kitchen table, where did you eventually place them? Did your carefully arranged bouquet of mixed wildflowers move to a table near a sun-filled window? Did you arrange the fruits in a bowl or leave them in the basket, setting them on the kitchen counter to ripen some more?

You can capture each scene, whether at the farmers' market or on your dining room table, using watercolors, oils, pastels, colored pencils—whatever your medium of choice. Mother Nature will provide you with the inspiration; this book will provide you with the tips and techniques of skilled artists and the keys to painting your own beautiful fruit and flowers.

left
TERESA STARKWEATHER
Sunflowers & Coffee
Watercolor, 40" × 30" (102cm × 76cm)

Composing and Drawing Flowers

What is more refreshing than walking through a field of wildflowers or a summer garden in full bloom? What is it that captures our eyes and minds—the delicate petals; the soft, sweet scents; the vast array of color?

For centuries, artists have been capturing the beauty of flowers—from wild-growing meadows to arranged floral still lifes.

Here you will learn basic, yet important, elements of composing and drawing flowers. Learn from these pages, then capture the beauty of the countless varieties of flowers awaiting you.

Dogwood

Dogwoods are trees with circle-shaped flowers. Their petals twist and turn with a downward motion.

A As they sit on the branch the ellipse of each blossom is at a different angle.

B White flowers can be a challenge. The subtle value change between petals may be only a single thin glaze of value.

C Cast shadows add interest to this group of dogwoods with definition and movement.

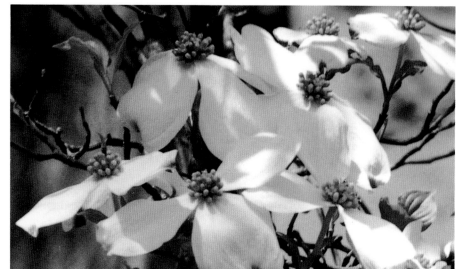

Reference Photo

B Value changes between similar petals add definition

A Ellipses at different angles add variety

C Cast shadows add interest

Daffodil

Daffodils, a springtime favorite, are cone-shaped flowers that can be found in a variety of colors.

A The center of a daffodil extends beyond the circular petal, so when you paint the center, the values must relay this information. The center of this daffodil is where the darkest dark and the lightest yellow of the stigma meet.

B Since the center of the daffodil extends, a reflected color glow was created on the back petals. The artist, Arleta Pech, used a thin glaze of Burnt Sienna and Cadmium Orange for this.

C This petal is a good example of how to make a petal roll. Use a deeper value on the underside of the petal, then a softer value on the upper right edge, leaving the leading front curl almost white.

D The other important observation is where the petals overlap.

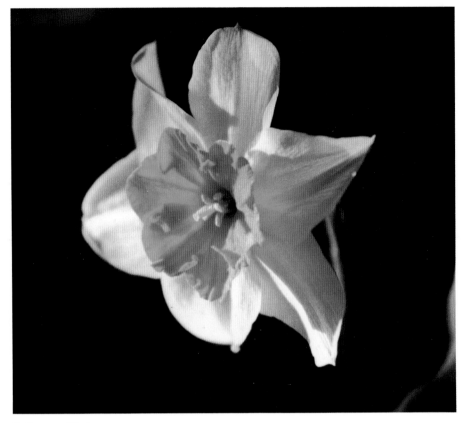

Reference Photo

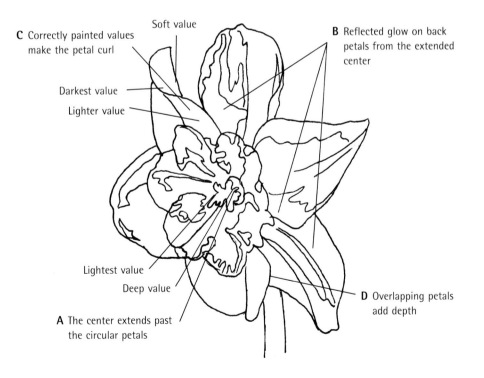

C Correctly painted values make the petal curl

Soft value

B Reflected glow on back petals from the extended center

Darkest value

Lighter value

Lightest value

Deep value

A The center extends past the circular petals

D Overlapping petals add depth

Iris

The iris is a favorite of Pech. Each petal is circle shaped.

A White flowers resonate with the colors around them; this iris is no exception. The spring green color is reflected from the surrounding foliage. The artist used New Gamboge and Cobalt Blue to demonstrate this.

B The peach color from the center beard was repeated through the surrounding petals.

C One of the most exciting elements of the iris is the transparent top petals. This area is great for leaving lost and found edges created by the light and shadow.

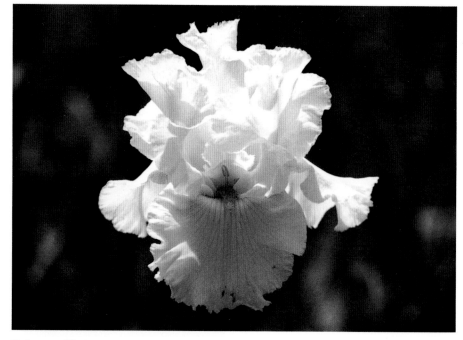

Reference Photo

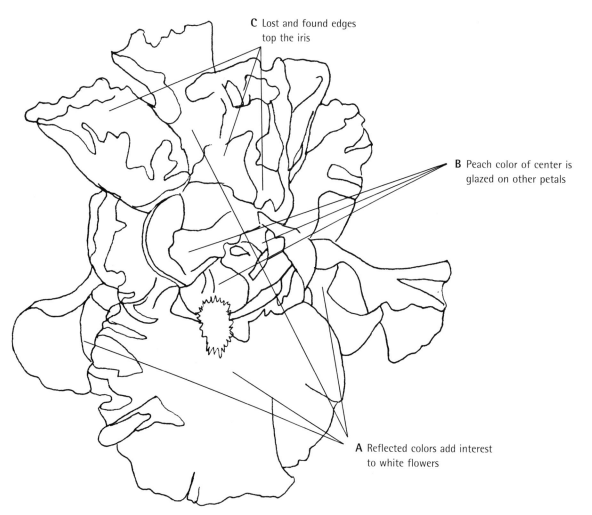

C Lost and found edges top the iris

B Peach color of center is glazed on other petals

A Reflected colors add interest to white flowers

Tulips

The tulip, another springtime flower, is shaped like a cup.

A The curve of the petals in the center shows the depth and angle, which are two important parts of perspective.

B The light source here hits the left side petals and then bounces to the lower right petal's edge.

C A deeper value used in the center contrasting with the light-value petals shows depth.

D The cast shadow adds definition to the side view of the tulip. Notice the different values within that cast shadow.

Reference Photo

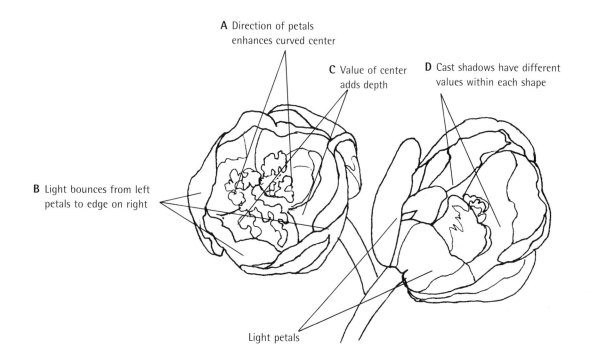

A Direction of petals enhances curved center

C Value of center adds depth

D Cast shadows have different values within each shape

B Light bounces from left petals to edge on right

Light petals

Roses

The rose's circle shape is made by overlapping circles.

A When working a complicated flower like a rose, paint the underside petals first, which helps you to see the complicated layers.

B Work from dark to light in your painting pattern. This allows you to save white highlights that add sparkle.

C Overlapping and layered petals add depth. A simple value change on each petal adds dimension to your flower.

Reference Photo

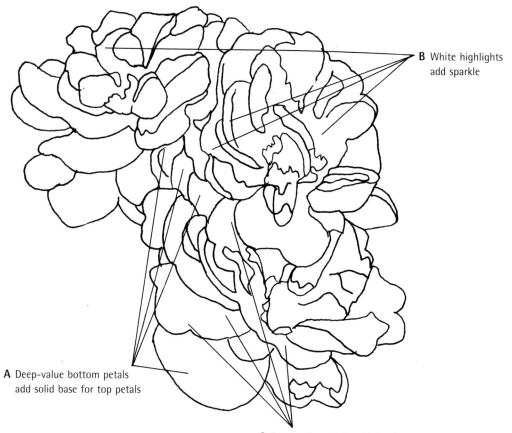

B White highlights add sparkle

A Deep-value bottom petals add solid base for top petals

C Overlapping petals add depth

Peonies

Peonies are complicated flowers. The outside petals form circles, surrounding frilly, multipetaled centers.

A Start with the outside petals. Notice the strong cast shadow, which gives weight and definition to the center.

B Now that the outside petals have form, notice the underside of the multipetaled center and how the values go from deep to light, showing direction and movement.

C Keep it simple. Use light and shadow to simplify the center of the peony. Paint just a few crevices. Don't outline each petal. Let your negative shapes dominate and it will still read as a full-blown peony.

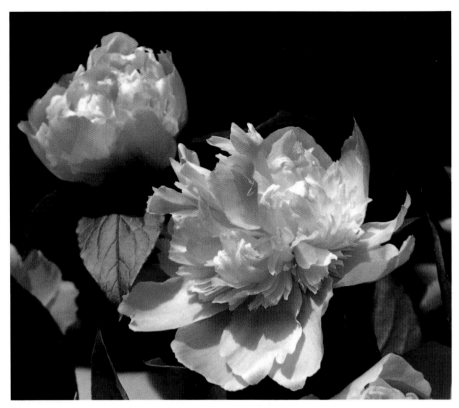

Reference Photo

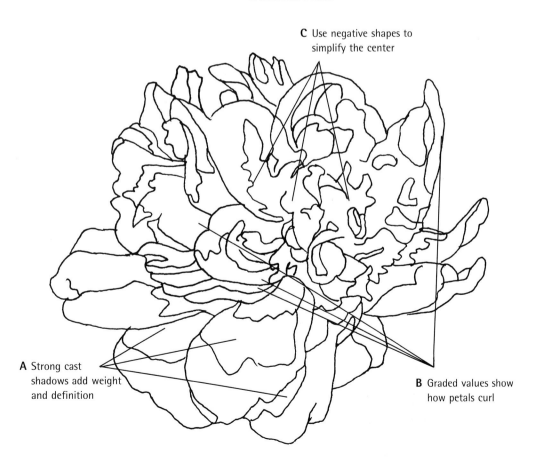

C Use negative shapes to simplify the center

A Strong cast shadows add weight and definition

B Graded values show how petals curl

Arranging a Floral Still Life

You don't have to paint exactly what you see, especially when painting a floral. Even the best floral setup gets somewhat simplified and rearranged on the paper. It's just part of the process. Nevertheless, starting with a poor subject puts you at an immediate disadvantage.

CREATING DOMINANT AND SUBORDINATE MASSES

When you arrange your floral, create dominant and subordinate masses. You don't want all your flowers to say "hello" at once. Group similar blossoms; overlap shapes to unify them; interrupt hard edges with overlapping elements. Try placing some flowers, petals or leaves on the table to create eye movement, and keep shapes pointing toward the point of interest.

USING LIGHTING AND BACKGROUNDS TO BRING OUT THE POINT OF INTEREST

As you work with lighting and backgrounds, save the strongest contrasts, brightest lights and purest colors for your point of interest. Shadows give your subject drama, depth and contrast. Dark backgrounds work best, with little or no definition, to bring out the brightness of the flowers. The artist, Marilyn Simandle, tends to minimize, or entirely lose, the back edge of the setup table. It's generally an unnecessary distraction.

Too Much Going On
You don't know what to look at first. The reds compete for attention, sending your eyes all over the place. Even the three pots compete, with their similar shapes and busy patterns. Avoid frequent repetitions of elements that are the same size, color or shape.

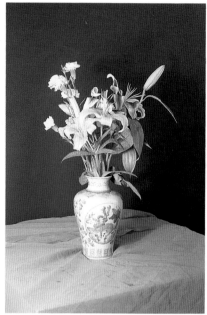

Top-Heavy Composition
All the interest here is massed at the top, like a lollipop on a stick, which presents composition problems.

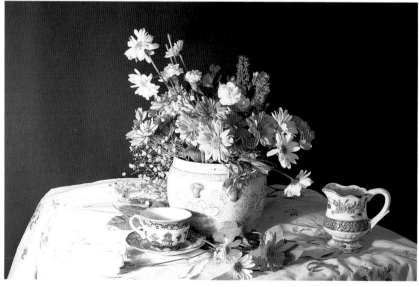

A Good Arrangement
There's good contrast in the sizes of the elements here. Flower shapes break the line of the pot's rim. Flowers and leaves placed casually on the table lend an informal air and provide opportunities to move color around. When you arrive at a pleasing arrangement, study it from various angles.

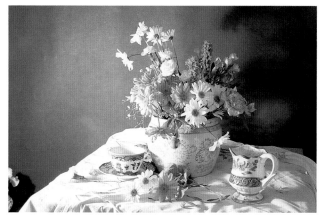

Moving to the Right
The setup still works!

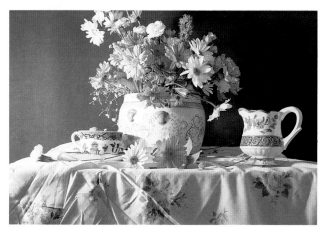

Low Viewpoint
This kind of angle is quite dramatic.

High Viewpoint
A very high viewpoint can also be exciting.

Getting Up Close
Standing too far away is a common mistake. Try moving in really close. It's fine to let your arrangement run right out of the picture area because the edges of your paper are part of the composition, too. Looking through a little viewfinder (made by pushing the film out of a 35mm slide holder, for example) helps you compose your subject in this way.

Painting Flowers, Fruit and Vegetables in Watercolor

Flowers, fruit and vegetables offer a wealth of textures, shapes and colors for artists to re-create. Even the most discriminating of artists will be inspired and challenged by the countless products of Mother Nature—the subject matter and opportunities are endless.

DEMONSTRATION: WATERCOLOR

Basic Techniques for Realistic Flowers

ARLETA PECH

The following demonstration illustrates the basic techniques Pech uses in her paintings.

1 PAINT AND PULL BACKGROUND TO SET THE TONE

Begin each painting by placing the darkest darks in the background. This contrasts with and enhances the feeling of light on the subject, and sets up the value against which you will judge all of your other values.

You can mix the colors on your palette or let the colors mingle on the paper. Use little water to mix the darks, but the paint must be fluid. Keep in mind the colors of your center of interest so that your background color complements it. The artist used Hooker's Green Dark and Antwerp Blue here. She also wanted a warmer, antique background, so she also used Burnt Sienna with a touch of Permanent Rose.

Use a good-size brush that allows you to load and release the paint. A 1-inch (25mm) flat or ¾-inch (19mm) angular brush, depending on the surface size, works well.

Load the brush with one color and touch it to the dry paper at an edge or corner where the subject runs off the paper. Use the brush to pull the color, carefully filling

in the background around the flowers, teapot and table. Think of mopping a floor. Control the paint as it leaves the brush, dragging it thinner and creating different values to yield a modeled wet-into-wet look on dry paper.

Change brushes for each color. Here the colors are the same intensity, and the only

change is in the coolness or warmth of the color itself. It's easy to build rich, intense color using this technique.

Finish with the small background shapes, such as holes in the lace or space between petals. Let the background dry completely.

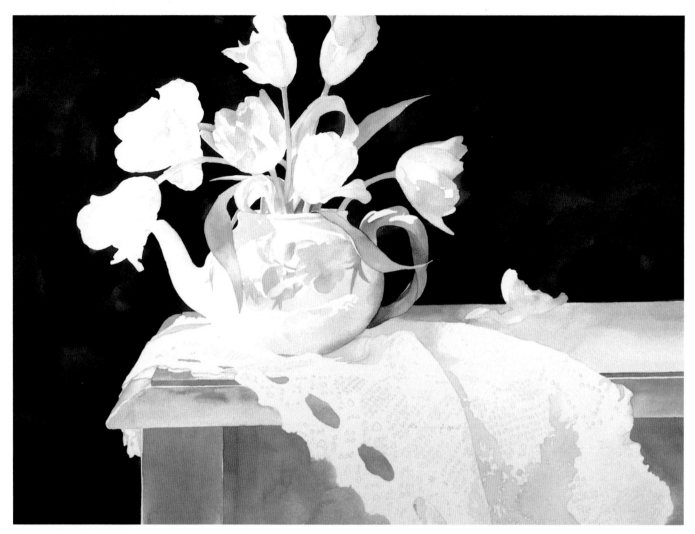

2 SAVE WHITES WITH FIRST CRITICAL GLAZES

Now you're ready to apply the first pale-value glaze. This glaze will start to give the painting a three-dimensional look while saving the white highlighted areas. If done correctly, it will look like sunlight hitting the petals, leaves and other surfaces.

Mix thin puddles of local color on your palette and apply the first glaze to a petal. Pay close attention to where the value changes on that petal. Start where the color will be deepest, and gently pull the color thinner toward the highlight. The color should move smoothly into the white highlight, so soften this edge with a clean, damp brush.

Repeat, reloading your brush as needed, until a light glaze is over the painting. Paint petals or leaves one at a time. Skip around so they don't run together. Above all, leave the white alone, even if it needs to be toned down later. Don't rush. Don't go too dark too fast. This glaze should be pale. It's easier to correct a light value than to try toning down a deeper color. Yet even now, think about making a petal or leaf dimensional; notice where the deeper values are and whether they have a flat or graded color.

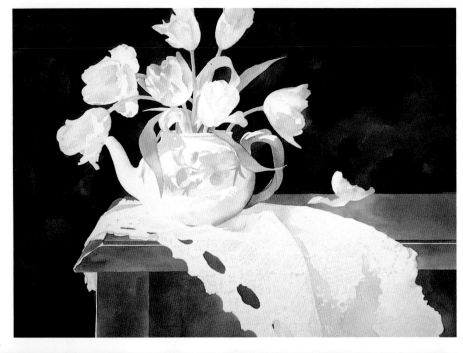

3 CREATE DIMENSIONS WITH SUCCESSIVE GLAZES

The second glaze deepens shadow values in all areas. Develop them petal by petal, leaf by leaf, like the first glazes. Keep in mind what the local, or midrange, color is while painting graded values to build depth. Paint less area in the third glaze, while still saving white highlights. Build glazes of color, paying close attention to how values build the form. Colors will become richer and values deeper with each layer. Allow each glaze to dry thoroughly before applying the next so the paint remains transparent. Glazing over damp paint will result in muddy colors.

Start pushing value extremes at this stage, creating areas of greatest contrast. When you start glazing the petal of a flower, work on progressively smaller and smaller areas of the petal with each successive glaze. Soften the edge of each glaze with a clean, damp brush, which will create subtle gradations of value from light to dark and contribute to a feeling of depth. The number of glazes will depend on how deep you want an area to look. This artist's work averages five to ten glazes to create the depth of color that portrays a realistic curve or depth.

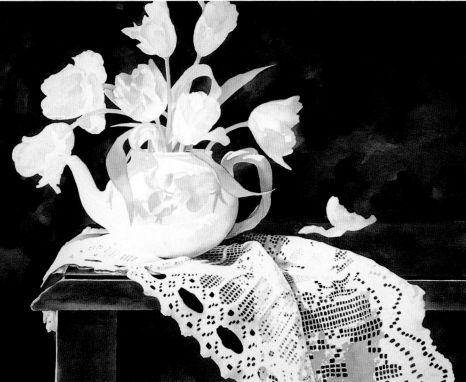

4 FINISHING DETAILS

An airbrush can be used in the final stages of a painting to tone an area or push a portion of the subject into the background without disturbing the existing glazes. For example, you can use an airbrush to darken the edge of a vase. Arleta Pech prefers to use an airbrush in a loose manner rather than with stencils. Use tissue paper to cover areas where you don't want the color.

You're in control. Have fun, and don't try to make your painting exactly like photo references. Change it to fit your mind's eye. The fun is deciding which areas to play up and which to push into the background. It's amazing how you can change a watercolor in the final glazes.

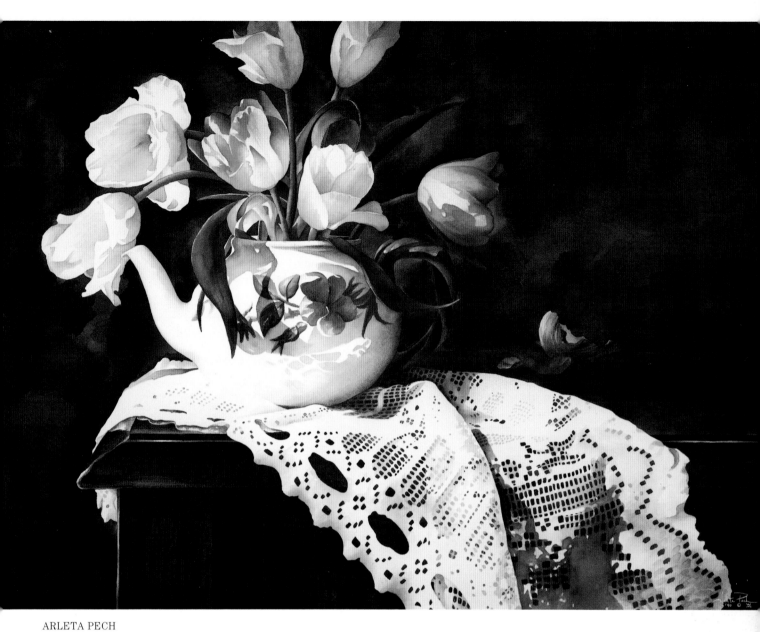

ARLETA PECH
Tea Time Tulips
Watercolor, 20" × 28" (51cm × 71cm)
Courtesy of the artist and Mill Pond Press, Inc.

Starting With the Background

ARLETA PECH

Before you begin this demonstration with a three-color background, practice painting a one-color background around a simple shape of a flower. Mix a large puddle of color, keeping it fluid—you don't want the paint so thick that it's paste. Load your brush so it almost drips with color, and start painting where the flower leaves the page. Work away from the color you just laid down, because you don't want to disturb the paint you just applied. As you practice, notice the intensity of your color and how much paint you need to keep in the brush in order to keep the paint flowing.

A WET-INTO-WET LOOK ON DRY PAPER

To get value changes in all this beautiful color, use brush pressure to release the paint, then pull the remaining paint to leave thinner areas next to richer areas. Keep the thinner areas fluid. After you refill your brush, touch the edge of the last area you painted to avoid hard brush lines. The effect is a wet-into-wet look on dry paper that also provides control for going around your subject.

MORE THAN ONE COLOR

When using more than one color, allow the brushloads to overlap so the paint can mingle. When working with several colors, use a brush for each so there's no need to rinse the brush between color changes. The backgrounds are one of the loose areas of Pech's paintings, and she's always surprised how they turn out.

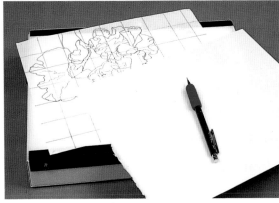

The color swatches for the background, using Antwerp Blue, Hooker's Green Dark and Winsor Violet.

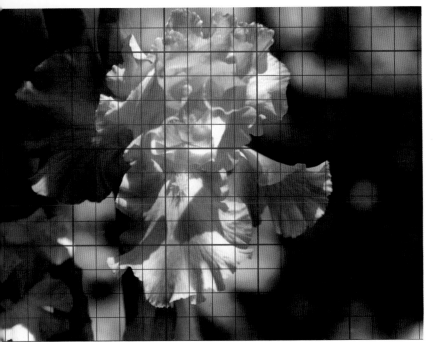

1 DRAW A GRID

Create a grid drawing and transfer the drawing to watercolor paper. Use a lightbox or tape the drawing to a window in order to transfer it, or use any other means of tracing.

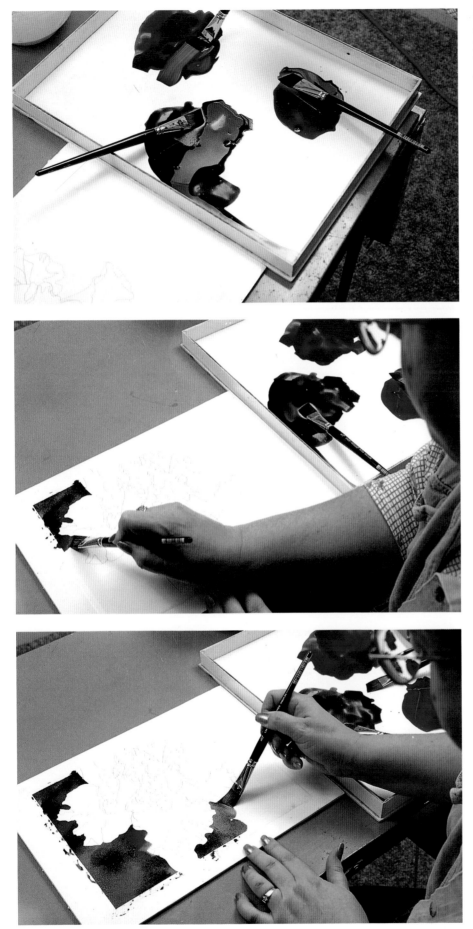

2 PUDDLE COLOR
Make big, juicy color puddles on your palette. When you run your brush through them, you should see the white of the palette. Use a different brush for each color.

3 START THE BACKGROUND
Start the background in the upper left-hand corner where the iris stem goes off the page. Use Hooker's Green Dark and Antwerp Blue on the dry paper.

4 WORK AROUND THE DRAWING
Using a different brush for each color, work around the drawing of the iris. Change colors at random.

5 ADD COLOR

Use brush pressure to dump a quantity of paint, then pull it thinner, keeping the color wet enough to mingle on the paper.

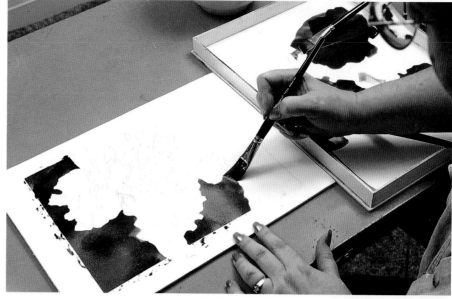

6 WORK AWAY FROM THE COLOR

Turn the paper as you work, painting away from the color just laid down. This will keep your color fresh and won't disturb the paint while it's setting up. Lighten the color here by adding water to your brush and pulling the color thinner.

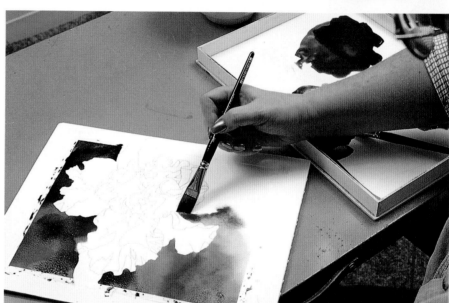

7 WORK COLORS MORE

After using lighter colors on the right-hand side, Antwerp Blue and Winsor Violet, work back into deeper colors in the upper right-hand corner.

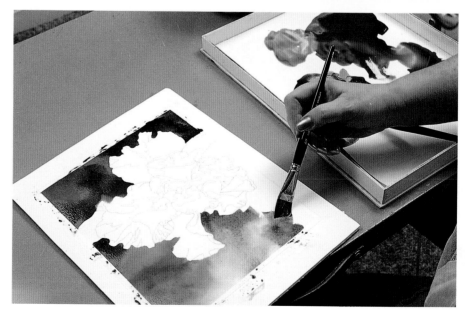

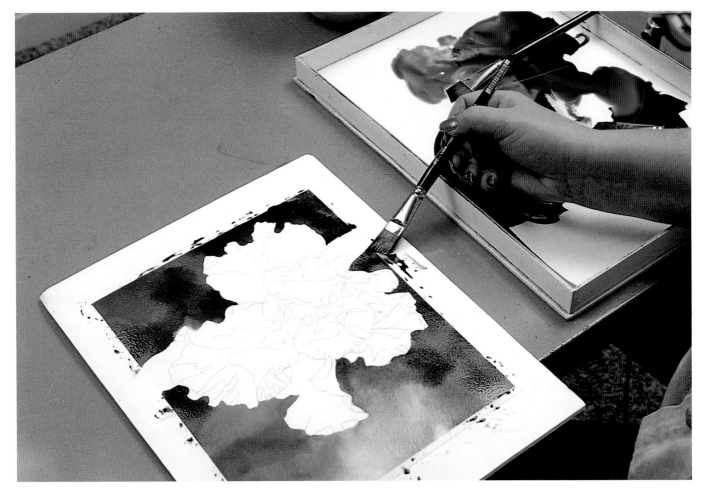

8 FINISH THE BACKGROUND
As shown in steps three through seven, complete the background.

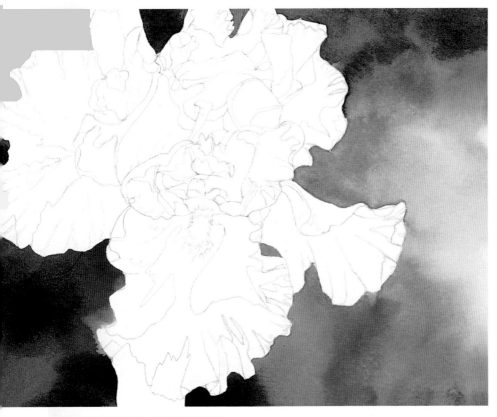

DETAIL OF FINISHED BACKGROUND

TIP The key to beautiful jewel-tone backgrounds is using just one layer so the color is fresh. If your backgrounds are spotty, load your brush more often to keep an even moisture level. If your backgrounds are streaked, you're pulling your color out too far and it's drying too fast. Think of mopping a kitchen floor and pulling the moisture along as you work.

USING GLAZES TO FINISH THE IRIS

Once the background is complete, use the glazing technique to finish the painting. *Glazing* is the process by which thin layers of watercolor are permitted to dry, allowing the underlying paper or color to show through, no matter how many glazes are applied. This gradual building up of color eliminates the problem of muddy colors.

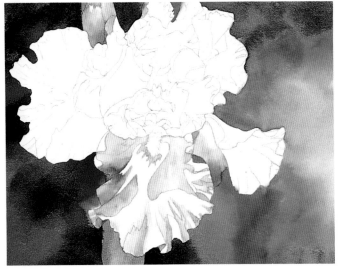

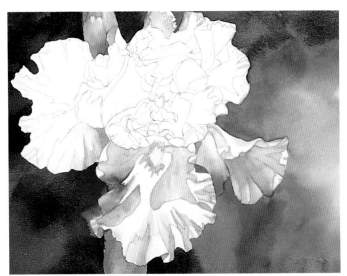

9 BEGIN WITH THE LOWER PETAL
Apply a thin glaze of Winsor Violet in the deepest area of color, pulling the glaze out to a lighter value. Glaze Burnt Sienna in the warm color areas. Use New Gamboge, Antwerp Blue and Burnt Sienna for the stem.

10 PAINT THE NEXT PETAL
Break the flower down into shapes and values, which will help simplify the painting process. Continue around the entire flower.

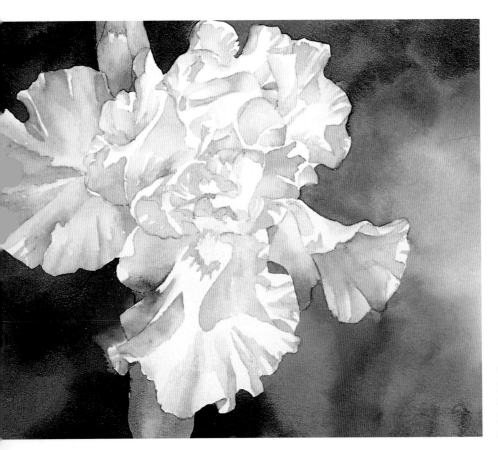

11 REMOVE PENCIL LINES
This shows the iris with the first glaze of Winsor Violet and Burnt Sienna complete. Notice the white areas of paper left for sunlight highlights. Gently remove the pencil lines now. If left through the second glaze, they won't erase.

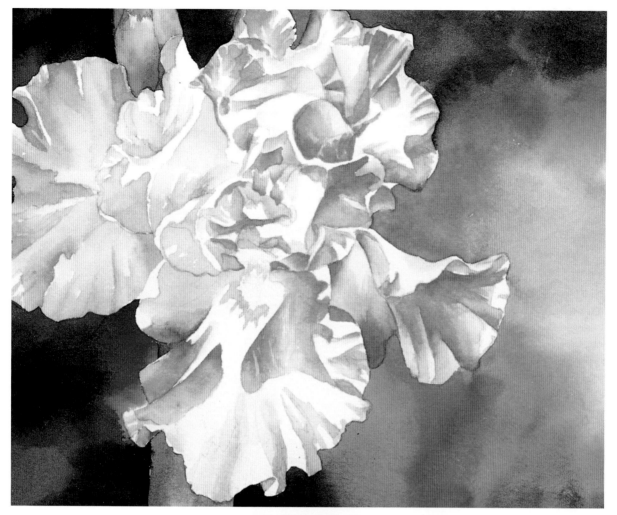

12 APPLY THE SECOND GLAZE

Using the same intensity as for the first glaze, start where the color will be deepest on each shape and soften out to the first-value glaze. Here, the second glaze of Winsor Violet has been applied to the bottom petal and the petal to its right. Continue around the flower. Remember, don't go too dark too fast.

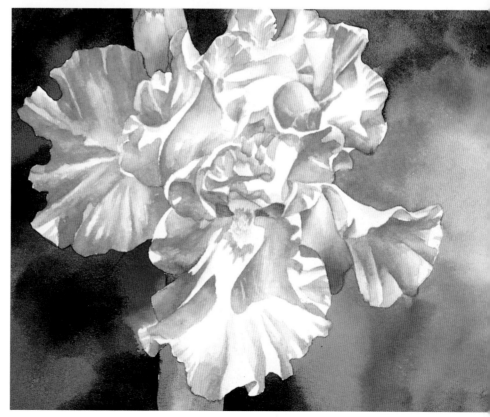

Completed Second Glaze

13 CONTINUE GLAZING

The final iris was glazed four times, but notice not all the shapes received the last glazes. Some only have two glazes, which adds depth to the iris. In the third glaze, mix Antwerp Blue with Winsor Violet for a cool color to enhance the shadow area. Pech used her airbrush to tone down the far left petal and the curl of the far right petal. She used the airbrush freely and didn't cover any areas with tissue, so there are a few places where the airbrushed color floated onto other areas.

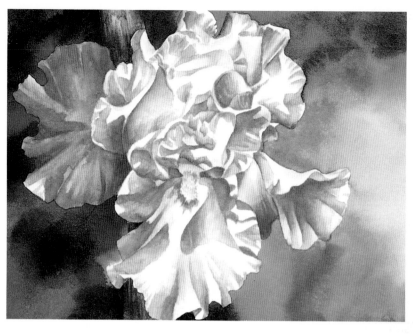

Background started

Burnt Sienna touches for warmth

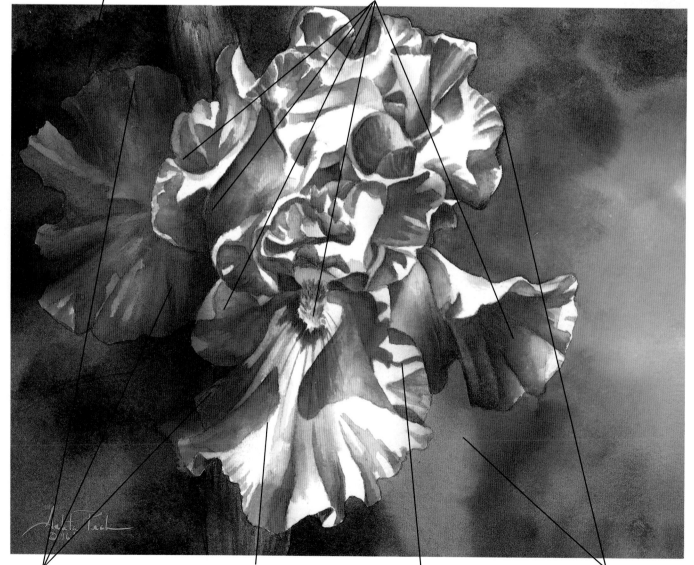

Airbrush toning

White of the paper for sunlit highlights

Airbrush float of color

Lighter background colors

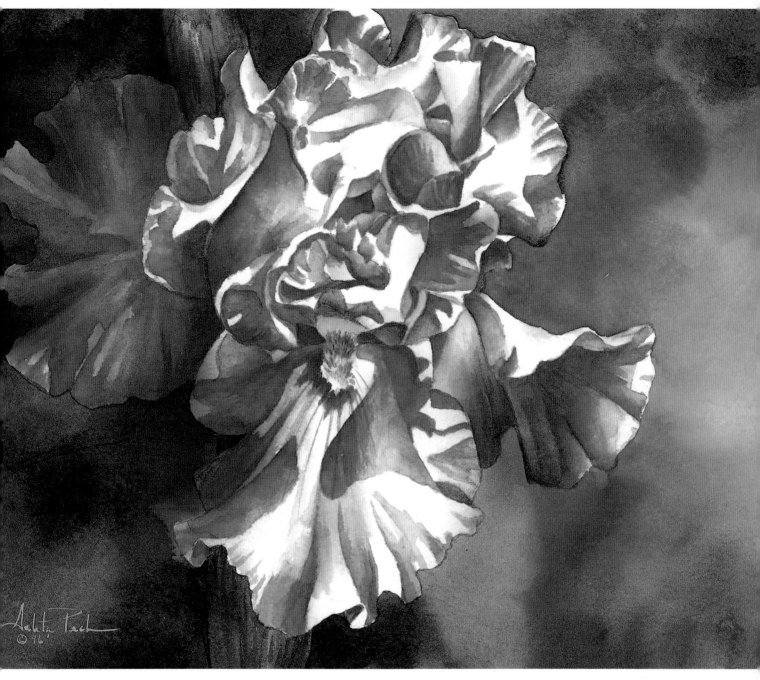

ARLETA PECH
Iris
Watercolor, 11"×14" (28cm×36cm)

Vegetables on a Cutwork Cloth

DAWN McLEOD HEIM

In this project, you will learn how to paint vegetables that have differently textured surfaces. For the smooth and shiny vegetables, like the eggplant and pepper, you will be using layered washes of transparent staining color. For the turnip, you will be using mainly nonstaining colors.

You will also learn how to enhance a cast shadow by using various colors from your subject matter, as well as how to duplicate the thickness of a cutwork cloth and create the illusion of holes by painting just the shadow shapes in the pattern.

MATERIALS

Paints
Colors by Daniel Smith Extra
Fine Watercolors
- Carbazole Violet
- Carmine
- Green Gold
- Permanent Brown
- Sap Green
Colors by Winsor & Newton Selected
List Artist's WaterColours
- Burnt Umber
- French Ultramarine Blue
- Hooker's Green Light
- New Gamboge
- Permanent Rose
- Winsor Blue

Color by Holbein Artists' Watercolor
- Sap Green
Brushes
- no. 4 round, with a nice point
- no. 6 round, with a nice point
- no. 8 round
- no. 10 or no. 12 round
- small scrubber brush
Other
- A quarter-sheet, 11″×15″ (28cm×38cm), Arches 300-lb. (640gsm) cold-press watercolor paper

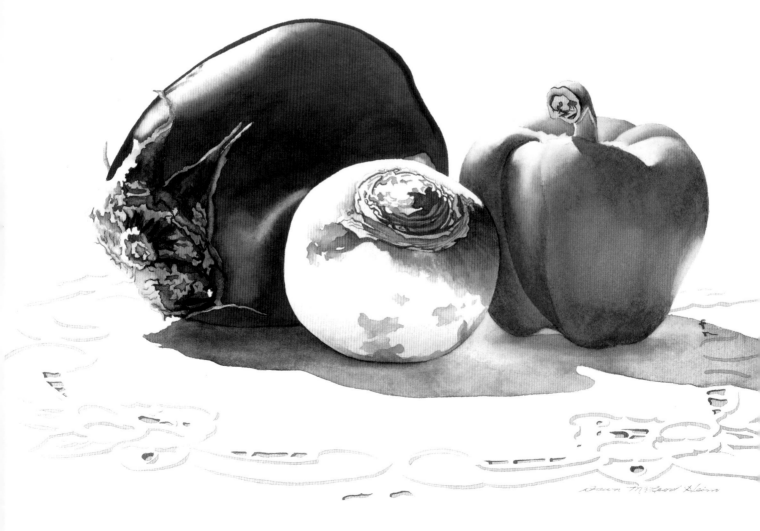

Transfer this drawing onto your watercolor paper, enlarging or reducing it as needed.

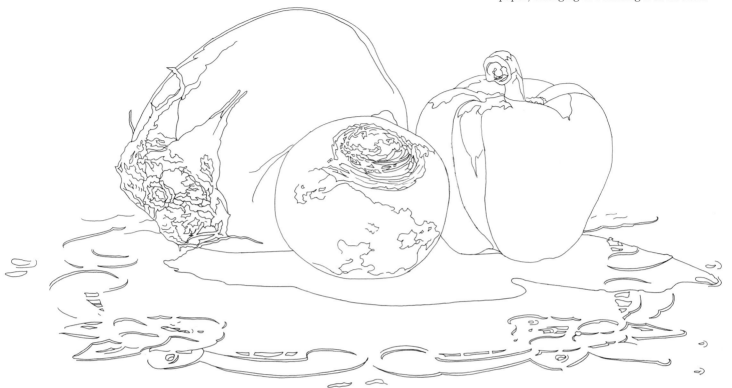

COLOR KEY

A Burnt Umber
B Permanent Rose + Carbazole Violet
C Sap Green (H)
D Winsor Blue + Carbazole Violet
E Carmine + Winsor Blue
F Green Gold
G Hooker's Green Light
H Permanent Brown + Carbazole Violet
I Sap Green (H) + French Ultramarine Blue
J Sap Green (D.S.)
K Hooker's Green Light + Sap Green (D.S.)
L French Ultramarine Blue + Permanent Rose + New Gamboge = grayed blue

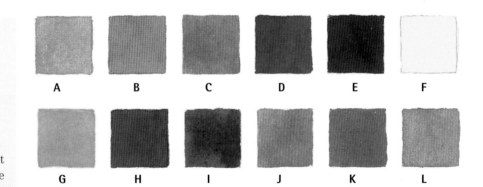

UNDERPAINTING COLOR AND TEXTURE IN VEGETABLES, AND HOLES IN THE CLOTH

1 PAINT THE TURNIP

Take a brushload of **A** and make a new puddle, adding enough water to make a light value. Fully load your brush with the light value, and paint across the bottom of the turnip. Soften the upper edge with water. Continue softening upward until your wash is clear. Quickly load your brush with **A** and apply a continuous brushstroke of color along the bottom edge, allowing the color to gently charge upward. Let dry.

With **A** still in your brush, paint the brown spots and all the brown areas on the top, softening some of the edges, as shown (page 33). Rinse your brush and blot well.

Load your brush with **B** and paint all the pink areas, softening some of the edges and touching the damp wash randomly, making the surface appear blotchy.

Load your brush that has a nice point with **B** and paint all the narrow areas on the top.

2 PAINT THE EGGPLANT

Paint the purple-and-blue areas of the eggplant twice. Load your brush with **A** and paint the center area of the stem. Let dry. Load your brush with **C** and paint all the green areas, charging in with water to vary the value. (Some areas should have **A** charged in.) Let dry.

Load your brush with clean water and wet the area along the top of the eggplant, as shown. Fully load your brush with **D** and, when the sheen is almost gone, paint the blue area at the upper right and along the lower right edge of the water, allowing **D** to gently charge upward. Immediately blot your brush well, fully load it with **E** and continue painting along the lower edge of the water, allowing **E** to gently charge upward. Blot your brush.

Fully load your brush again and continue painting the eggplant, using light brushstrokes in a back-and-forth motion similar to that of a windshield wiper, pausing often to fully load your brush. Carefully paint around the reflection of the green pepper.

When you reach the reflection of the turnip, take a separate brush that is loaded with **A** and gently charge **A** into **E**. Switch back to your brush that is loaded with **E** and finish painting the rest of the eggplant. While your wash is still damp, take a clean, moist brush and lightly lift out a large highlight to the left of the turnip. Let dry. Repeat this step again.

3 PAINT THE PEPPER

The yellow and green areas of the pepper are painted twice. Load your brush with **A** and paint the end of the stem. Let dry. Paint the rest of the stem and the upper-back sections of the pepper next. Load your brush with **F** and paint as far as is shown. Rinse and blot your brush. Load your brush with **G** and charge into **F**. Finish painting the rest of the section with **G**, allowing it to dry before painting the section next to it.

Divide the large areas in the front into three sections. Paint the left one first. Load your brush with **F** and paint a small area below the white highlight. Blot your brush. Fully load your brush with **G** and quickly paint the rest of the section, loading your brush often to maintain a large bead. Next, paint the section on the right. Load your brush with **F** and quickly paint the areas on the upper left and upper right, then cover the large area in the middle with water. Keep moist.

Fully load your brush with **G**. Starting directly below the stem, quickly paint downward and across the top area. Allow **G** to charge into the lower wet edges of **F**, using slightly overlapping brushstrokes. Work quickly down to the middle area that has been made wet with water, quickly painting down the left side of that section and along the bottom of the pepper.

Go back up to your wet edge and, with light brushstrokes, paint over the center section. Paint to the bottom of the pepper with the lightened value of **G**. Do not reload your brush. Mop up any excess color. Let dry.

Paint the middle section next. Load your brush with **F** and paint a small area below the highlight. Blot your brush. Quickly load your brush with **G** and finish painting that section. Once dry, repeat this step again to deepen the values.

4 PAINT THE CLOTH

Load your brush with **A** and paint all the hole shapes shown in the sample.

TIPS Remember to rinse and blot your brush well before moving on to a new color. If too much color charges into the water area along the top of the eggplant, try lifting out some of the color while the wash is still damp. Otherwise, wait until both steps two and six (see page 34) on the eggplant have been painted, then gently scrub out some of the color using your scrubber brush.

When you are painting the green areas on the pepper, try to work quickly. Hooker's Green Light is a highly staining color that locks color into your paper instantly. If you are not familiar with this color, Heim recommends practicing on a piece of scrap watercolor paper first.

When you are finished with steps one through four, your painting will look like this.

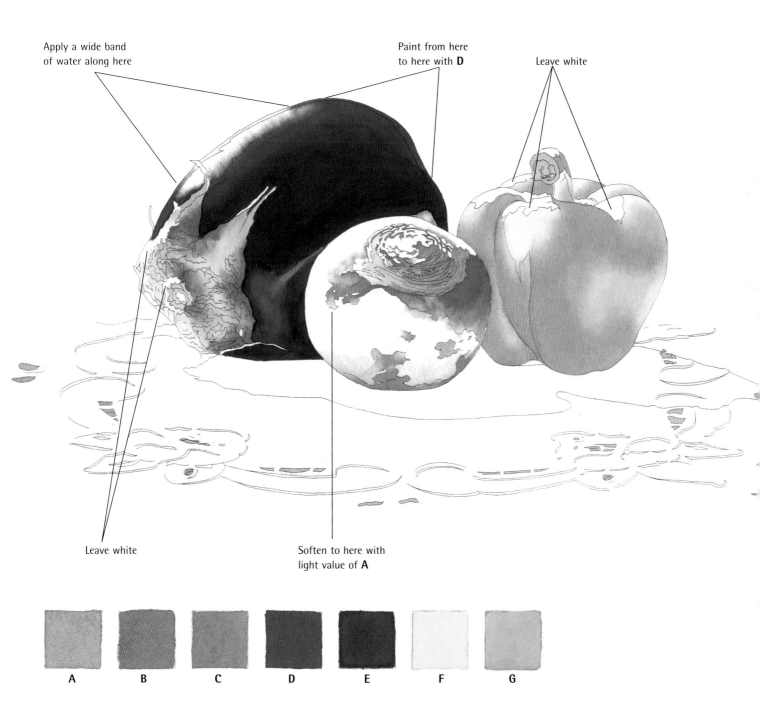

Apply a wide band of water along here

Paint from here to here with **D**

Leave white

Leave white

Soften to here with light value of **A**

A B C D E F G

DEEPENING VALUES IN VEGETABLES; PAINTING THE CAST SHADOWS AND THE CLOTH PATTERN

5 PAINT THE TURNIP

Load your brush with **A** and paint the areas at the bottom of the turnip. Rinse and blot your brush. Load your brush with **C** and paint those areas (top of turnip).

Load your brush with **B** and paint all the pink areas on the top, charging in with **H** on some of the areas, and softening the edges as shown on page 35.

Load your brush that has a nice point with **H** and paint along the lines (shown in the samples) for the top of the turnip.

6 PAINT THE EGGPLANT

Load your brush with **E** and paint the area between the line and the outer edge along the top of the eggplant, softening the lower-right edge with water, lightly glazing over the reflection of the pepper. When completely dry, paint the same area again; this time, do not glaze over the reflection of the pepper.

Load your brush with **I** and paint all the green areas, softening the edges, as shown in the sample. Let dry.

Finally, load your brush with **H** and paint all those areas, softening most of the edges as shown.

7 PAINT THE PEPPER

Paint the stem and all the upper-back sections of the pepper first. Load your brush with **J** and paint the areas shown in the sample, then soften with water. Let each section dry before painting the one next to it.

Using light brushstrokes, paint the front sections of the pepper in the same manner as in step three, but with **J** and **K**. Charge the colors together, as shown. Let dry. Load your pointed brush with **H** and outline the areas on the top of the stem, softening some of the edges.

8 PAINT THE CAST SHADOW

Paint the complete shadow, working from left to right. Start under the eggplant and charge the colors, using continuous overlapping brushstrokes in the following order: under the eggplant, use **C, H, E, I** and **B**; under the turnip, use **C, B** and **L**; under the pepper, use **C, K, C** and **L**.

When completely dry, load your brush with **H** and paint the shadow again just under the eggplant and the turnip, softening the edge outward with clean water.

Load your brush with **K** and paint under the pepper a short distance. Dip the tip of your brush into **H** and paint under the rest of the pepper with the **K/L** combination. Soften the edge outward with clean water.

9 PAINT THE SHADOWS IN THE CLOTH

Load your brush with **H** and paint all the shadows in the holes. Rinse and blot your brush. Next, load your brush with **L** and paint all the areas between the lines on the cloth's pattern.

TIPS When painting the pepper, remember to work quickly because of the highly staining character of Hooker's Green Light.

After rinsing your brush between colors in the cast shadow, blot your brush well to prevent any unwanted ballooning effects.

A B C

E H I

J K L

Top of Turnip

First, paint these areas with **H**; let dry.

Next, soften the edges with a clean, moist brush.

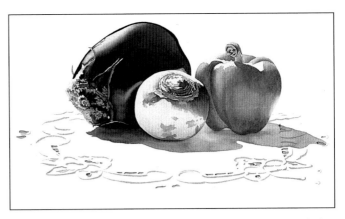

When you are finished with steps five through nine, your painting will look like this.

Line Outer edge

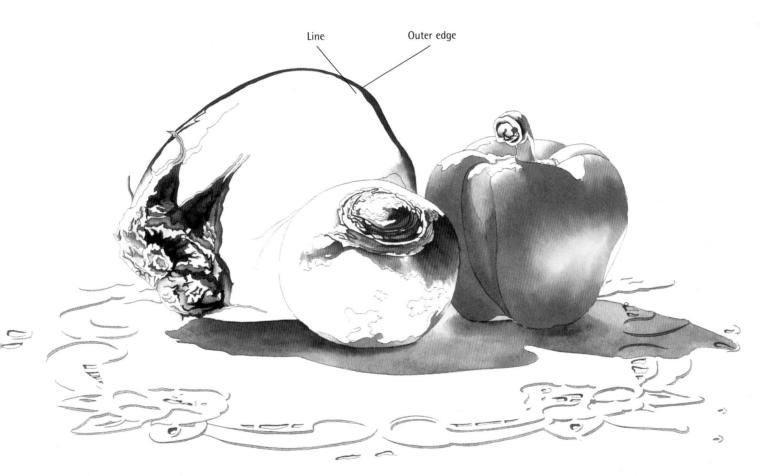

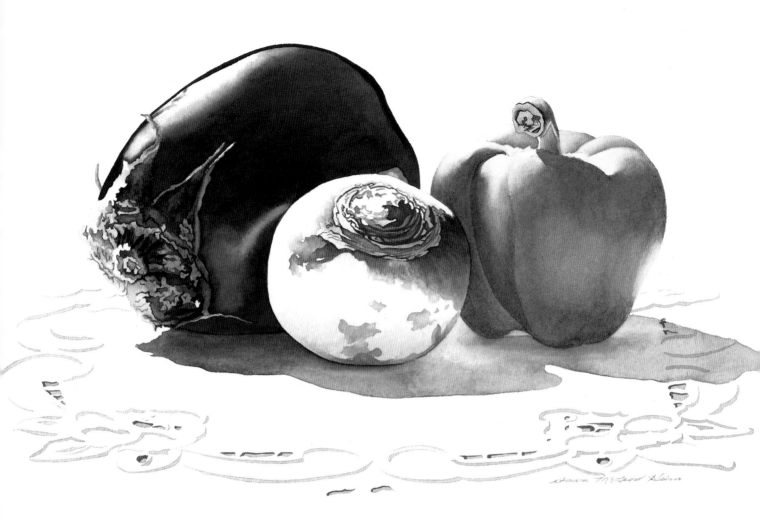

DAWN McLEOD HEIM
Vegetables on a Cutwork Cloth
Watercolor, 11"×15" (28cm×38cm)

10 SOFTEN THE HIGHLIGHTS

To soften the highlighted areas on the pepper, lightly scrub out the line that separates the white highlight from the yellow-green areas using short brushstrokes. Scrub just a few strokes at a time and blot each time you scrub. Make sure you rinse your scrubber brush often so that you do not scrub the color back into the area you are trying to lift the color from, especially the white areas. Scrub into the colored area as shown in the finished painting above, brushing in the direction of the roundness of the pepper and blotting lightly. Be sure to expose some of the **F** and **G** colors that are underneath.

CRITIQUING YOUR WORK

Now that you have completed all the steps, compare your painting and its values to the finished painting at left. Take a look at your

• Turnip. If the brown color took over your pink and dulled it, lightly scrub out the dulled color, let dry, then glaze over the pink area with a light value of Opera, which is a slightly opaque, bright pink color made by Holbein. This will help punch up the color. The dark brown areas should be really dark. If they aren't, go back in and darken them.

• Eggplant. If your value is too light, repeat the layering process with the purple and blue colors until it closely matches the value in the painting at right.

If you lost your white highlight along the top, take your scrubber brush and gently scrub out the color, blotting with a paper towel, not a tissue. (A tissue will leave lint particles on the dark pigment.)

If you lost your lighter green areas in the front, take a clean, moist brush and gently tickle the color, then blot with a paper towel.

The brown areas should be very dark for contrast. If they are not dark enough, paint them again, but use a lighter value.

• Pepper. If you feel that you have overworked the shadow color on your pepper, or have made it too dark or gummy looking, take a clean, moist brush and lift off all the shadow color, blotting with a paper towel. The Hooker's Green Light will still be visible because of its staining power. Let dry completely. Then go back and paint with the shadow colors again, using light brushstrokes.

• Cast shadow. If your shadow is too dark, lift out some of the color near the turnip and the pepper, then blot. The shadow color by the eggplant can remain dark.

If you feel that your shadow is too blotchy and spotty, take a brush fully loaded with water and paint over the entire shadow, tickling the areas that are blotchy or spotty, and finish painting the shadow. Let dry.

• Cloth. If your values do not look like the ones in the painting at left, adjust them accordingly.

Cluster of Berries

DAWN McLEOD HEIM

In this lesson, you will learn how to paint berries to make them appear three-dimensional, as well as which colors you can use to make them appear lush and ripe. You will also learn how you can add more texture to your leaves by using a sedimentary color, such as Manganese Blue.

MATERIALS

Paints
Color by Daniel Smith
Extra Fine Watercolors
 • Cobalt Blue
Colors by Holbein
Artists' Watercolor
 • Manganese Blue
 • Sap Green
Colors by Winsor &
Newton Selected List
Artist's WaterColours
 • Alizarin Crimson
 • French Ultramarine
 Blue
 • Winsor Blue
 • Winsor Red
Brushes
 • no. 6 round, with a
 nice point
 • no. 8 round
 • no. 10 or no. 12 round
 • scrubber brush
Other
 • A quarter-sheet,
 15″×11″
 (38cm×28cm),
 Arches 300-lb.
 (640gsm) cold-press
 watercolor paper

Transfer this drawing onto your watercolor paper, enlarging or reducing it as needed.

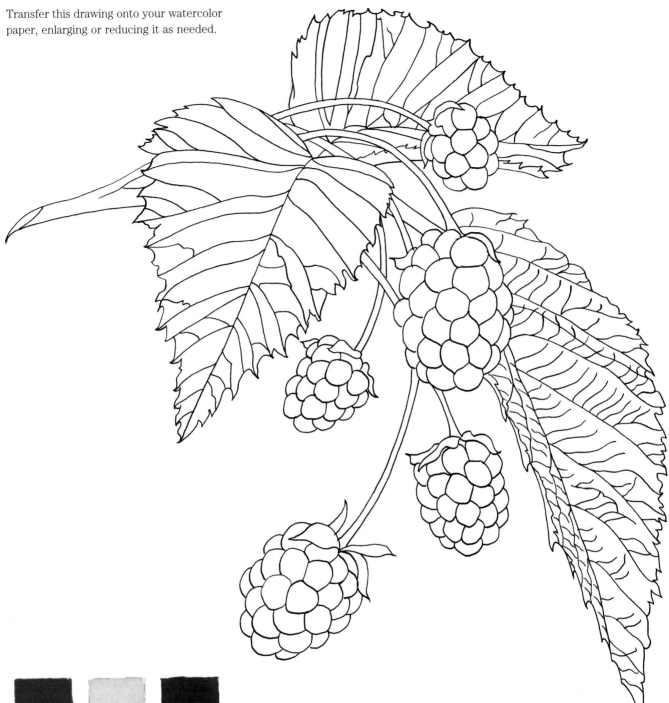

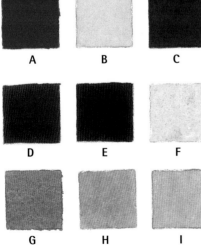

COLOR KEY
A Winsor Red
B Sap Green
C Alizarin Crimson
D Alizarin Crimson + Winsor Blue
E French Ultramarine Blue + Alizarin Crimson
F Sap Green + Manganese Blue (lt./ med.)
G Manganese Blue + Sap Green (dk.)
H Sap Green + Alizarin Crimson
I Cobalt Blue

UNDERPAINTING COLOR ON BERRIES AND LEAVES

1 REMOVE EXCESS GRAPHITE FROM BERRIES

With your kneaded eraser, remove enough graphite from the berrries to make the lines barely visible.

2 PAINT THE BERRIES

You will need two brushes: one for pigment, another for clean water. Start with the small berry at the top. Load your pigment brush with **A** and paint a short distance. Rinse and blot your brush. Load your brush with **B** and charge into **A**. Finish painting the segment with **B**. Paint all the segments on the right in the same manner.

Load your brush with **B** and paint all the segments on the left side following the directions in the sample below. Let dry. Paint all the segments on the left side twice. Paint the other **A/B** combination berry in the same manner.

Continue to paint the other three berries with the same technique shown in the sample, using the colors indicated. Remember to let each segment dry completely before painting the one next to it.

3 PAINT THE LEAVES

With your kneaded eraser, lift off most of the graphite from the highlight line that separates the darker area from the lighter area. Paint the leaf on the left first. Load your brush with **B** and, starting at the center vein, paint the area between the side veins. Let dry. Continue to paint the rest of the areas on the leaf in the same manner, letting each section dry before painting the next one.

With **B** still in your brush, paint the underside of the top leaf and the curled-over sections of the leaf on the right. Rinse your brush and blot well. Load your brush with **F** and paint those sections on the other two leaves. Let dry.

4 PAINT THE STEMS

Load your brush with **C** and, starting with the main stem on the far left, paint along the top as shown (at right). Rinse and blot your brush. Load your brush with **F**, and charge **F** into **C**. Finish painting the stem with **F**. Repeat the same for the section of stem between the two leaves.

Load your brush with **B** and paint all the narrow fruit-bearing stems, as well as the tiny leaves on top of each berry. Be sure to let each one dry before painting the one next to it.

TIP Always stir puddles containing Manganese Blue before loading your brush. Otherwise, your brush will pick up all the sediment that settled at the bottom of your puddle.

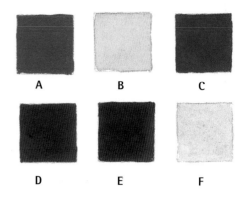

A B C

D E F

Some segments have a white highlight

First, apply a brushstroke of color and keep it moist

Next, soften the edge with water and keep new edge moist

Finally, rinse out your brush and blot well; finish softening the edge; let dry

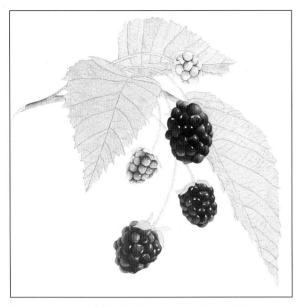

When you are finished with steps one through four, your painting will look like this.

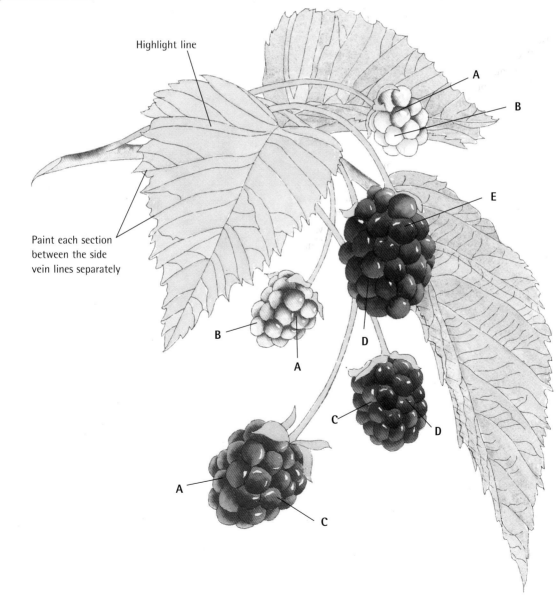

Highlight line

Paint each section between the side vein lines separately

A
B
E
D
C
D
B
A
A
C

PAINTING THE BACKGROUND AND SHADOWS ON THE BERRIES AND LEAVES

5 PAINT THE BERRIES

Load your brush with **H** and, starting with the berry at the top, paint between the segments on the left side, softening the edges as shown (at right). With **H** still in your brush, paint the segments on the left side of the other berry in the same manner. Let each segment dry completely before painting the one next to it. Continue to paint the areas between the segments using the colors shown in the sample and soften the edges on the left. Let dry.

6 PAINT THE LEAVES

Paint the leaf on the left first, starting at the top. Load your brush with **B** and paint along the long side vein and up to the highlight line, softening along the edge as shown. While the wash is still moist, load your brush with **G** and paint along the same vein again, allowing **G** to charge upward into **B**. *Do not paint upward with* **G**. Continue until all the sections on that leaf are painted.

Paint the leaf on the right next. Load your brush with **F** and, on the far right, paint along some of the long side veins again, softening with water as shown.

Load your brush with **G** and paint only those small, dark vein lines, softening each vein line with water as shown.

Load a nicely pointed brush with **B** and paint only those small vein lines on the left side of the leaf. Do not soften the edges. Still using **B**, paint the small vein lines on the right side of the leaf, softening each vein with water as shown.

Load your brush with **H** and paint only those side vein lines on the left side of the same leaf. Do not soften the edges. With **H**, also paint the small veins on the right side of the leaf, softening those edges with water. Let each small vein dry completely before painting the vein next to it.

Paint the sections on the top leaf with **B**, **F** and **G**, softening some of the edges with water as shown. Let dry.

7 PAINT THE STEMS

Load your brush with **C** and paint along the top part of the main stem. Quickly rinse your brush and blot well. Load your brush with **B** and charge **B** into **C**. Finish painting the rest of the stem with **B**.

Load your brush with **H** and paint a narrow strip of color along the underside of each of the long, fruit-bearing stems, gently softening to the right with a clean moist brush. With **H** still in your brush, paint the small leaves on the top of the berries, softening with water as shown. Let dry.

8 PAINT THE BACKGROUND

With color **I**, paint the background clockwise, rotating your painting so that you are always painting toward yourself. Turn your painting upside down and start on the right side by the end of the stem.

Fully load your brush with **I** and paint as far as the darkest value of the blue shown for that area. Dip your brush into your water container and slide it once against the rim. With light overlapping brushstrokes, paint toward yourself with the light value. Rinse your brush, slide it once against the rim and finish softening toward yourself with the clean water.

Continue to alternate between color **I** and the water until the background is completely painted. When you get to the narrow areas by the berries, switch to a smaller brush. Keep an eye on your edge so it doesn't dry out.

TIP To make painting the background easier, divide it into sections and let each section dry completely. Use clear water when overlapping into the previously painted area. You will get a smoother transition and avoid getting hard edges.

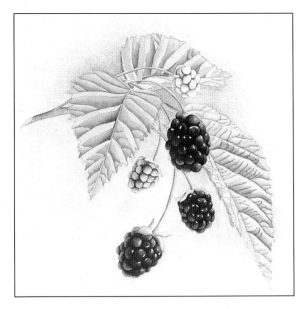

When you are finished with steps five through eight, your painting will look like this.

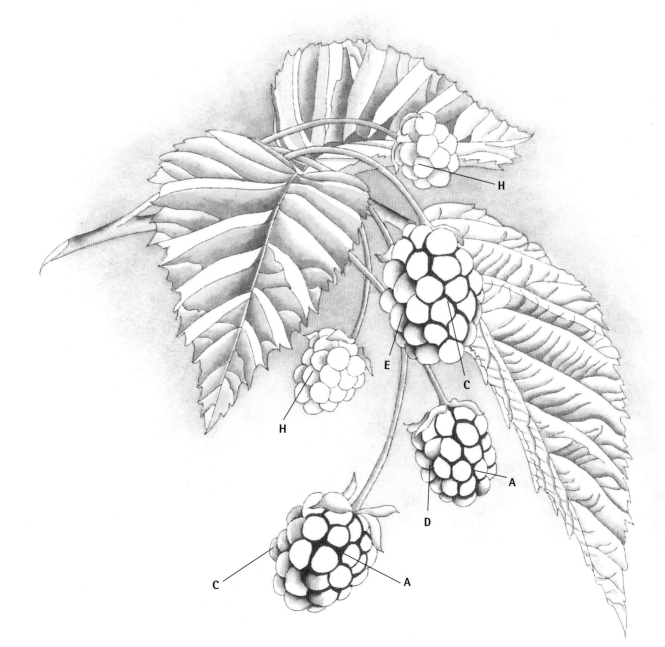

FINISHING TOUCHES

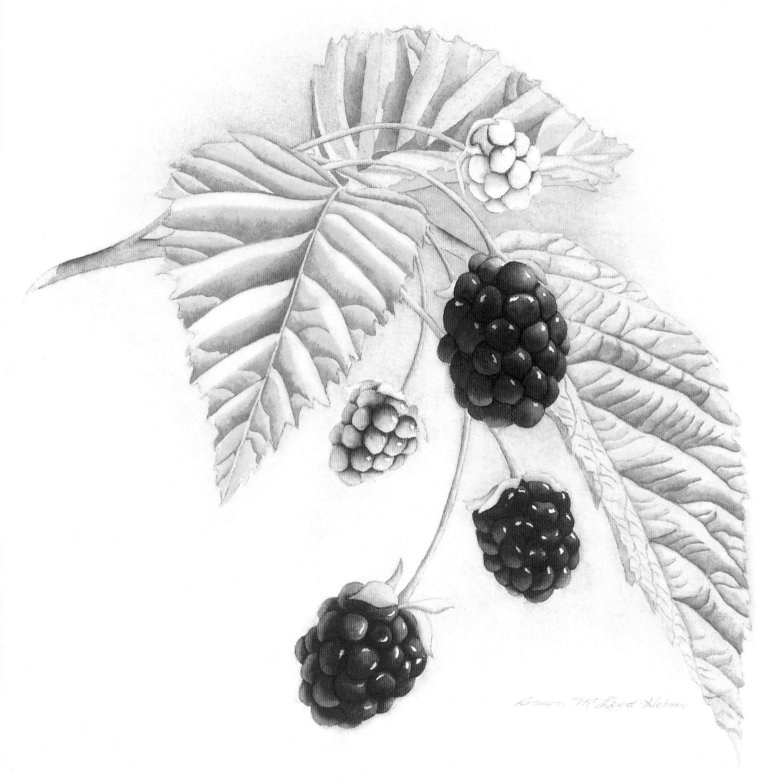

DAWN McLEOD HEIM
Cluster of Berries
Watercolor, 11"×9" (28cm×23cm)

9 HIGHLIGHTS

Take a clean, moist brush and lightly go over some of the highlights on the segments on the left side of the berries to help tone them down. With a scrubby brush, lightly lift out some of the color along and above the highlight lines on the left leaf.

CRITIQUING YOUR WORK

Now that you have completed all the steps, compare your painting and its values to the finished painting on the facing page. Take a look at your

• Berries. If the segments on the right side of the berries are too light, paint over them again with a lighter value of the color. If they are too dark, first try to lift some of the color, using a clean, moist brush. If that doesn't work, then use your scrubber brush and lightly lift out some of the color.

If you lost some of your highlight on the right side of the berries, add some using a tiny bit of acrylic white paint.

• Leaves. Are the values close to that of the finished project? If not, go back in and deepen the areas using a lighter value of that color. If the light areas in your leaves look too dark, gently lift out some of the color with your scrubber brush, then blot. If there is still not enough contrast between the light and dark values on the leaves, paint over all the dark values again.

• Background. If the value of your blue is too dark, take a clean, wet brush and rewet over the blue area, then with your paper towel blot up some of the color. If the blue areas are too light, paint over just the blue area again. Then with a clean, wet brush, gently charge clean water around the painted area, softening outward until the water is clean. Let dry.

If your blue took over your whole background, take your scrubber brush and lightly scrub out the blue, then blot. Continue working toward the berries and leaves until the amount of white you want is visible.

Adding Pen Work to Your Watercolor
Floral Pen Sketches

C L A U D I A N I C E

To maintain a delicate look when pen sketching flowers, choose a fine nib size (6×0 to 3×0) and avoid solid, harsh outlines.

Use contrast of value and texture to create natural definition where possible.

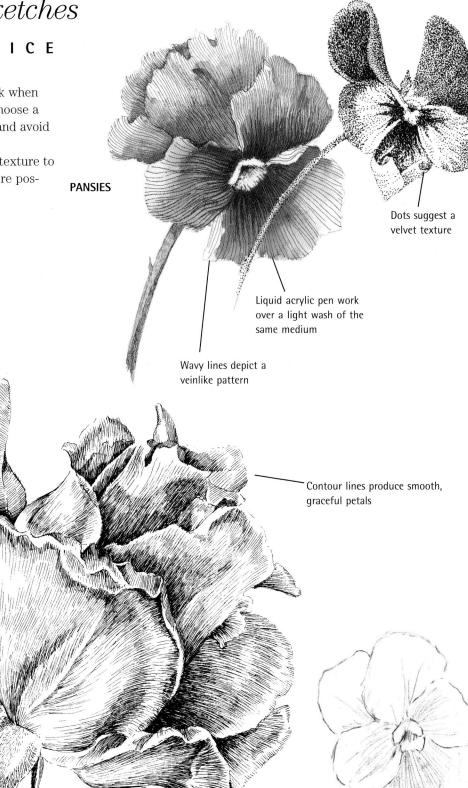

PANSIES

Dots suggest a velvet texture

Liquid acrylic pen work over a light wash of the same medium

Wavy lines depict a veinlike pattern

Contour lines produce smooth, graceful petals

ROSES

Preliminary pencil sketch

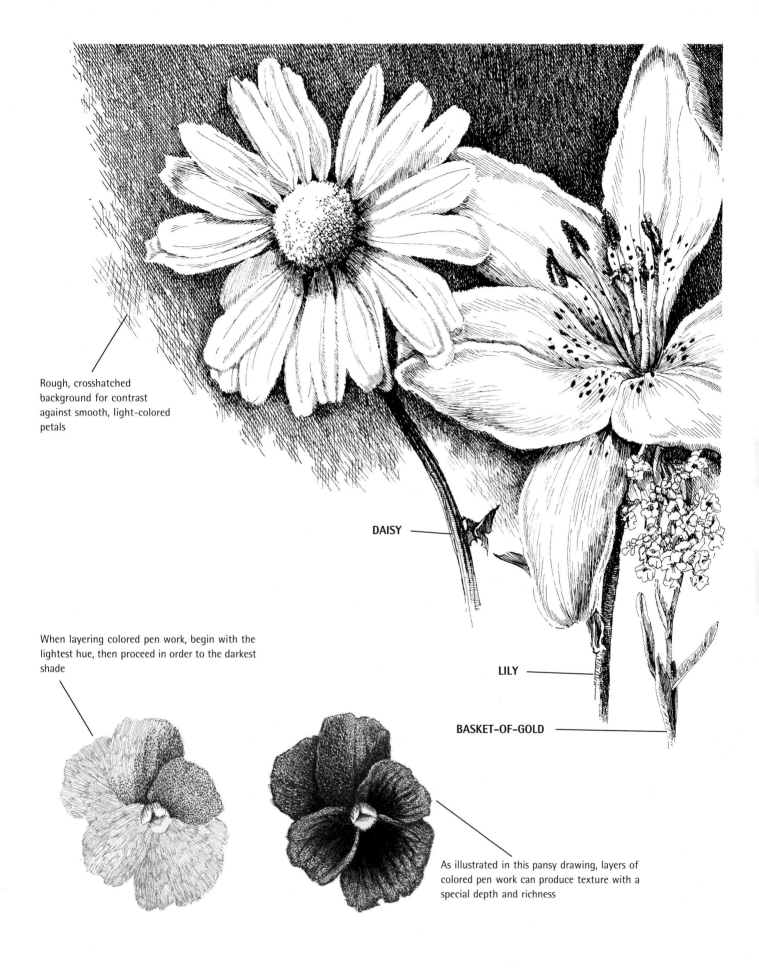

Rough, crosshatched background for contrast against smooth, light-colored petals

DAISY

LILY

BASKET-OF-GOLD

When layering colored pen work, begin with the lightest hue, then proceed in order to the darkest shade

As illustrated in this pansy drawing, layers of colored pen work can produce texture with a special depth and richness

Using White to Emphasize Color and Texture

MARY DeLOYHT-ARENDT

What is the real excitement of watercolor? Aside from the challenge of a medium that always surprises and delights, the paper itself plays a very important role. It is the paper that shines through those beautiful transparent glazes, the white that makes the watercolor painting sparkle, for which watercolorists aim.

When white space is used to separate primary colors, the colors remain strong and the whites appear to take on the same level of importance as the primaries. In Mary DeLoyht-Arendt's demonstration painting, *The Willow Chair*, the whites of the surrounding area emphasize the texture and color of the chair and flowers. These whites create an important quiet space that contrasts with the busy subject matter.

1 GET STARTED
Begin with a small compositional sketch to determine the size of the chair relative to the paper size, the importance of the wrought iron and the amount of white to remain.

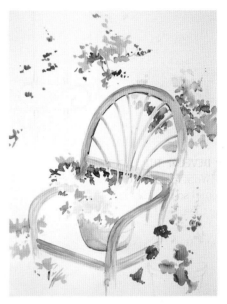

2 ADD THE FIRST WASH
On the painting surface, draw the chair, wrought iron and flower pots. Draw only the iron with precision; rough in the rest to indicate what the needs are. Wash in the chair shape and a few colors for flowers here and there, adding random shadows around where the white flowers will be.

3 DEVELOP THE CENTER OF INTEREST
To develop the center of interest, define the white flowers and chair by painting the negative shapes of greens and flowers. Next, establish the shadows on the cushion and bowl to show the light source, and add the wrought iron vertical.

4 ADD COLOR
Begin to fill in the colors, like putting together puzzle pieces, varying the shapes and values.

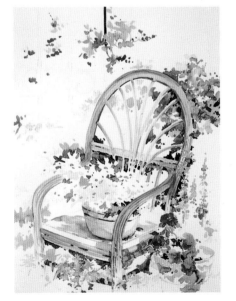

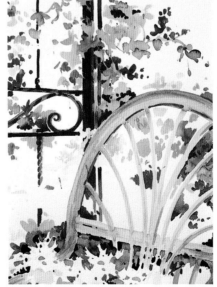

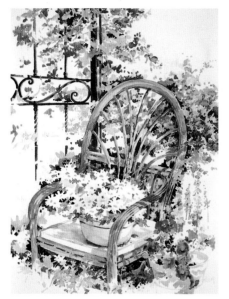

5 DEVELOP THE PAINTING

Work in different areas, skipping around so the whole painting develops at one time. Hold a mat up to the painting to find where there is too much white and where the wrought iron stands out too much. Place more color behind it and add some warm rust tones to the iron to avoid harshness.

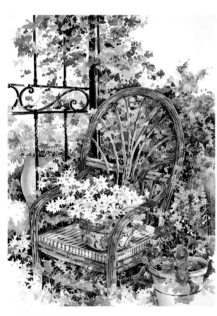

6 ADD DETAILS

Add stripes to the cushion and the designs on the pots. The strong structures of the gate and chair contrast against the more painterly flowers and leaves, a contrast of loose as well as controlled areas.

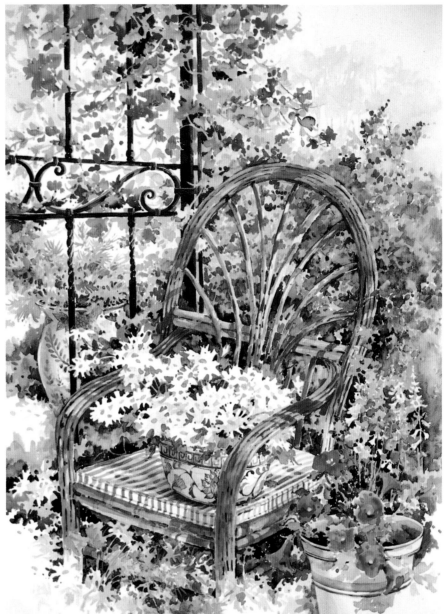

MARY DeLOYHT-ARENDT
The Willow Chair
Watercolor, 30″×22″ (76cm×56cm)

7 ADD THE FINISHING TOUCHES

Finally, add more color and a few very light washes to suggest trees in the distance. The white, a welcome relief from the activity going on elsewhere, is neither dominant nor unimportant. It isn't the center of interest, but it does add sparkle and a welcome calmness.

Colored Pencil Techniques for Flowers and Fruit

Think back to the garden at your childhood home, an outdoor market bursting with fresh produce and buckets of cut flowers, or perhaps a quaint garden you passed on a weekend drive. What captured your eyes, your senses? Was it a bed of tulips proudly erect after a brief spring shower? Sun-ripened tomatoes for sale, only a quarter a piece, at some roadside stand? Or how about the velvety blush-colored peaches hanging from a tree, ready to be picked, sliced and served over homemade ice cream?

Mother Nature provides quite a palette of color and texture, while colored pencils provide you, the artist, with yet another medium from which you can capture and enjoy nature's beauty. Offering versatility, control, simplicity and depth, colored pencils can be used on a variety of surfaces, such as drawing and watercolor papers and illustration board, just to name a few. Available in a wide range of colors, there's no limit to what you can draw or paint. So let's get started.

DEMONSTRATIONS: COLORED PENCIL

GARY GREENE

Rose

This photograph of a yellow-orange rose will reveal, under close scrutiny, a wealth of subtle hues too numerous to describe individually. By layering and burnishing various combinations of Sanford Prismacolor colored pencils, much of their subtle beauty can be attained. (Please note: Use of other colored pencil brands, such as Derwent, Lyra, Spectracolor and Verithin, are stated in parentheses.)

Folded Petals (Rose)—Left side layered only, right side burnished

Layered only

Burnished with White

Burnished with French Grey 10%

TYPICAL ROSE PETAL LAYERING

Layering and *burnishing* involves layering colors, one on top of the other, until the whole surface is covered. A white or very light colored pencil is then used to blend the layered colors.

The color palette is listed starting with the first color layered on the paper surface, usually the darkest, to the last, usually the lightest or burnishing color.

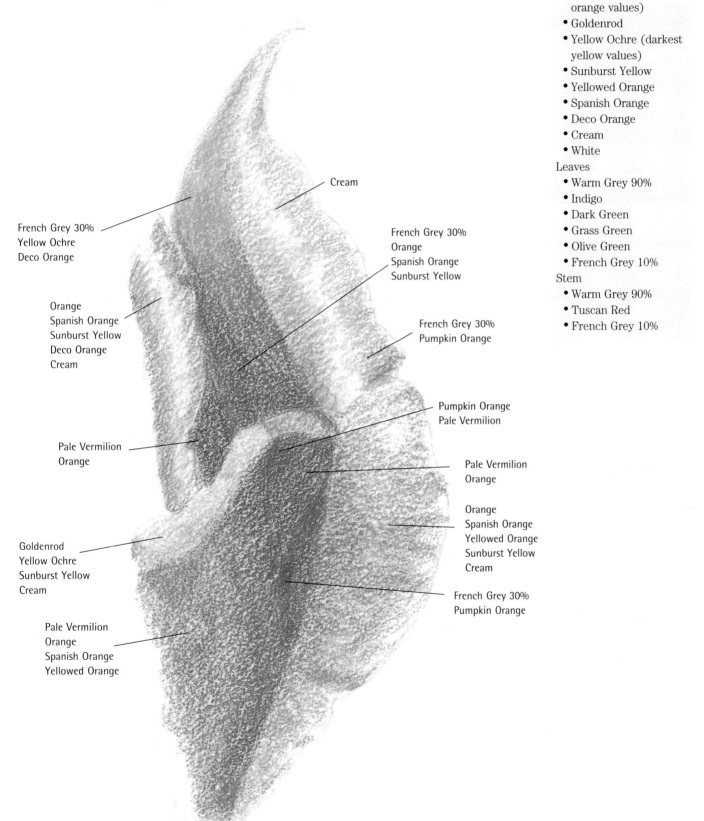

Cream

French Grey 30%
Yellow Ochre
Deco Orange

French Grey 30%
Orange
Spanish Orange
Sunburst Yellow

Orange
Spanish Orange
Sunburst Yellow
Deco Orange
Cream

French Grey 30%
Pumpkin Orange

Pumpkin Orange
Pale Vermilion

Pale Vermilion
Orange

Pale Vermilion
Orange

Orange
Spanish Orange
Yellowed Orange
Sunburst Yellow
Cream

Goldenrod
Yellow Ochre
Sunburst Yellow
Cream

French Grey 30%
Pumpkin Orange

Pale Vermilion
Orange
Spanish Orange
Yellowed Orange

Orchid

Orchids come in a multitude of sizes, shapes and colors. This subject was chosen for its variegations.

2 Layer Hot Pink, Pink and Peach. Wash with rubber cement thinner and a cotton swab. Lightly erase highlight area with kneaded eraser.

3 Layer Raspberry. Wash with rubber cement thinner and a cotton swab.

1 Layer Peach, Light Peach, Deco Peach and Jasmine. Wash with rubber cement thinner and a cotton swab.

5 Layer French Grey 30%, French Grey 10% and Cream. Burnish with Cream. Repeat layering as necessary.

4 Layer Dark Green, Olive Green and Apple Green. Burnish with Cream. Repeat layering as necessary, omitting Dark Green for each subsequent layer.

CENTER OF ORCHID

1 Layer Jasmine. Wash with rubber cement thinner and a cotton swab.

2 Layer French Grey 30% and Goldenrod. Wash with rubber cement thinner and a small watercolor brush.

3 Layer Henna, Raspberry, Hot Pink, Pink, Peach and Goldenrod. Wash with rubber cement thinner and a small watercolor brush.

4 Layer Sunburst Yellow and Goldenrod. Wash with rubber cement thinner and a cotton swab. Relayer colors from steps 1, 2 and 3, as necessary. Lightly erase the highlight area with a sharpened imbibed eraser and an electric eraser. Lightly burnish highlight with Jasmine and White.

5 Burnish spots with Henna using heavy pressure.

6 Dab spots with rubber cement thinner and a small watercolor brush.

PALETTE
Center
- Jasmine
- French Grey 30%
- Goldenrod
- Henna
- Raspberry
- Hot Pink
- Pink
- Peach
- Sunburst Yellow
- White

Petals
- Peach
- Light Peach
- Deco Peach
- Jasmine
- Hot Pink
- Pink
- Raspberry

Stem
- Dark Green
- Olive Green
- Apple Green
- Cream
- French Grey 30%
- French Grey 10%

1

2

3

4

5

6

Marigold

The marigold's two-tiered coloring lends itself to colored pencil painting with water and solvents.

Shadow accents with Yellow Ochre

Highlights—white on top of red

Layer with Warm Grey 70%, Dark Green and Olive Green, burnish with Cream and repeat as required

PETALS

1 Layer entire flower with Middle Chrome and Deep Cadmium.

2 Wash with water. Relayer with Middle Chrome and Deep Cadmium. Rewash.

PALETTE

Flower
- Middle Chrome
 (Derwent Watercolour Pencil)
- Deep Cadmium
 (Derwent Watercolour Pencil)
- Tuscan Red
- Crimson Lake
 (Spectracolor)
- Crimson Red
- Scarlet Lake
- Poppy Red
- Yellow Ochre
- White (center "berries" only)

Leaves
- Warm Grey 70%
- Dark Green
- Olive Green
- Cream

3 Layer with Tuscan Red, Crimson Lake, Crimson Red, Scarlet Lake and Poppy Red.

4 Wash with rubber cement thinner and a medium-small watercolor brush.

5 Burnish with Scarlet Lake (darkest areas only) and Poppy Red.

6 Wash with rubber cement thinner and a medium-small watercolor brush.

TIP Rubber cement thinner works like turpentine on wax- and oil-based pencils. Use rubber cement thinner in place of layering and burnishing to create a blended finish (as shown in step six).

Tulip

Like the rose, there are many subtle contours and colors in this smooth-textured tulip. Be certain to let the paper show through for the highlight areas.

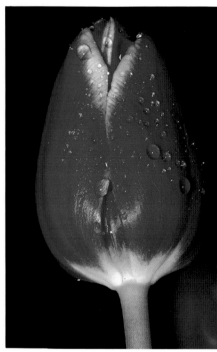

Reference Photo

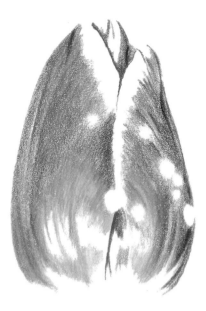

PALETTE
Flower
- Cool Grey 70%
- Tuscan Red
- Crimson Lake
 (Spectracolor)
- Crimson Red
- Magenta
- Carmine Red
- Cream
- White
- Cool Grey 20%

Stem
- Olive Green
- Light Yellow Green
- Apple Green
- Cool Grey 20%
- Cream

1 Following contours of flower, layer Cool Grey 70%, Tuscan Red, Crimson Lake, Crimson Red, Magenta, Carmine Red and Cream. Leave paper free of layering in highlighted areas.

2 Burnish with White except in the darkest areas.

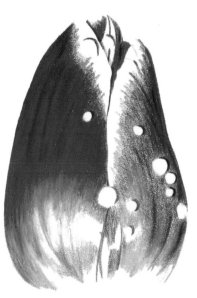

3 Relayer Crimson Lake and Crimson Red, Magenta, Carmine Red and Cream.

4 Reburnish with White and Carmine Red. In White areas, layer Cool Grey 20%, then burnish and drag with White. Add variegations in White areas with strokes of Crimson Red layered with Carmine Red, then lightly burnish with White. Layer stem with Olive Green, Light Yellow Green, Apple Green, Cool Grey 20% and Cream.

Tomatoes

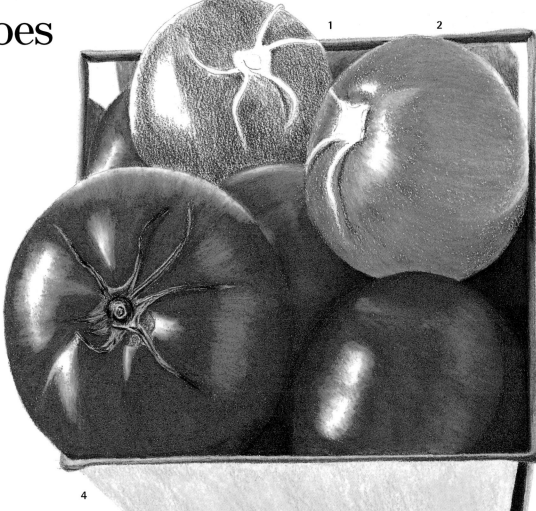

Here, sun-ripened tomatoes are carefully placed in a basket, the smooth red skins reflecting the late morning sun. As with the tulips, allow some paper to show through for the highlights.

1 Layer Crimson Lake, Crimson Red, Scarlet Lake, Poppy Red and Pale Vermilion. Leave the highlighted areas free of color throughout the process.

2 Burnish with White.

3 Layer/burnish Scarlet Lake, Poppy Red and Pale Vermilion (except lightest areas).

4 Burnish with Pale Vermilion. Sharpen edge with Carmine Red. For the stem, layer Warm Grey 90%, Dark Green, Olive Green and Goldenrod. Burnish with Cream. Layer Olive Green. Reburnish with Cream. Sharpen edge with Olive Green (Verithin).

 For the center, layer Goldenrod. Wash with rubber cement thinner and a small brush. Layer Light Umber.

PALETTE

Body
- Crimson Lake (Spectracolor)
- Crimson Red
- Scarlet Lake
- Poppy Red
- Pale Vermilion
- White
- Carmine Red (Verithin)

Stem
- Warm Grey 90%
- Dark Green
- Olive Green
- Goldenrod
- Cream
- Olive Green (Verithin)

Center
- Goldenrod
- Light Umber

Orange

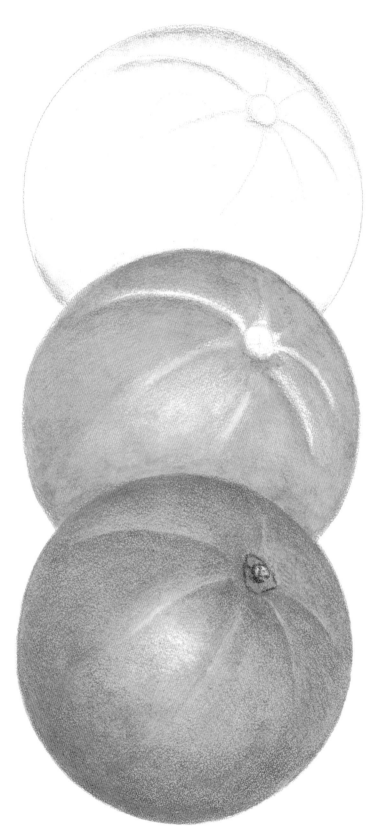

The tooth of the paper surface was used to help capture the texture of the orange's skin.

1 Layer French Grey 30%, French Grey 20% and French Grey 10%. Wash with rubber cement thinner and a cotton swab.

2 Layer Orange Chrome and Naples Yellow. Wash with water and a medium watercolor brush.

3 Layer Pumpkin Orange, Orange and Yellowed Orange. On the stem, layer and burnish Goldenrod, Olive Green, Light Umber and Cream.

PALETTE
Skin
- French Grey 30%
- French Grey 20%
- French Grey 10%
- Orange Chrome
 (Derwent Watercolour Pencil)
- Naples Yellow
 (Derwent Watercolour Pencil)
- Pumpkin Orange
- Orange
- Yellowed Orange

Stem
- Goldenrod
- Olive Green
- Light Umber
- Cream

Grapes

The frosted texture is depicted by randomly burnishing with white in the final step.

PALETTE
Body
- Black Grape
- Dark Purple
- Tuscan Red
- Raspberry
- Henna
- Sunburst Yellow
- White
- Tuscan Red (Verithin)
- Purple (Verithin)

Stem
- Apple Green
- Light Umber
- Cream

1

2

3

4

1 Layer Black Grape, Dark Purple, Tuscan Red, Raspberry, Henna and Sunburst Yellow. Leave the highlighted areas free of color throughout the process.

2 Burnish with White.

3 Layer/burnish Tuscan Red, Raspberry, Henna and Sunburst Yellow. Amounts of these colors should be varied, since no two grapes are exactly alike.

4 Burnish with White randomly. Sharpen edges with Tuscan Red or Purple (Verithin). For the stem, layer Light Umber with Apple Green, lightly burnishing with Cream. Repeat as necessary.

Strawberry

Strawberry seeds offer somewhat of a challenge to paint, but it's well worth the effort.

LEAVES

1 Layer Warm Grey 90%, Dark Green, Grass Green, Dark Green, Olive Green and Apple Green. Burnish with Cream in the lighter areas and Apple Green in the darker areas. Sharpen edges with Olive Green (Verithin).

PALETTE

Body
- Jasmine
- Burnt Yellow Ochre (Derwent Water-colour Pencil)
- Tuscan Red
- Crimson Lake (Spectracolor)
- Crimson Red
- Scarlet Lake
- Poppy Red
- White
- Carmine Red (Verithin)

Leaves
- Warm Grey 90%
- Dark Green
- Grass Green
- Olive Green
- Apple Green
- Cream
- Olive Green (Verithin)

BERRY

2 Burnish seeds with Jasmine. Wash with rubber cement thinner and a small brush.

3 Layer Tuscan Red, Crimson Lake, Crimson Red, Scarlet Lake and Poppy Red. Leave the highlighted areas free of color throughout the process.

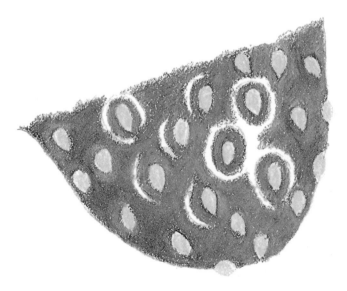

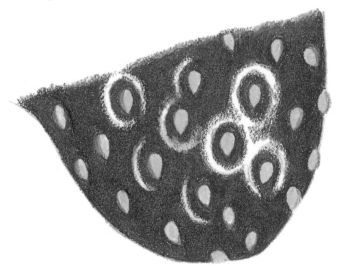

4 Burnish with White; do not apply White to seeds.

5 Layer/burnish Scarlet Lake and Poppy Red. Sharpen seeds with Carmine Red. Add shadows to the seeds with Burnt Yellow Ochre.

Bananas

With or without the peel, bananas can present a challenge for artists—from the smooth, waxlike texture of the skin to the cream-colored ripeness and bruising of the inner fruit.

1 Layer French Grey 20%, French Grey 10% and Yellow Chartreuse. Wash with rubber cement thinner and a cotton swab. Leave highlights clear until step three.

2 Layer Canary Yellow (Lyra) and Canary Yellow (Spectracolor).

3 Wash with rubber cement thinner and a cotton swab. Burnish with Cream. For the spots, layer/burnish French Grey 90%, Sepia and Dark Brown. Dab with rubber cement thinner and a cotton swab.

PALETTE

Body
- French Grey 20%
- French Grey 10%
- Yellow Chartreuse
- Canary Yellow (Lyra)
- Canary Yellow (Spectracolor)
- Cream

Spots
- French Grey 90%
- Sepia
- Dark Brown

Peach

To achieve the fuzzy texture, the final layer of color is wiped with a dry cotton swab rather than burnished.

1 Layer Spanish Orange, Yellowed Orange, Orange and Pumpkin Orange.

2 Wash with rubber cement thinner and a cotton swab.

3 Layer Crimson Lake, Crimson Red, Pale Vermilion and Pumpkin Orange. Burnish lightly with a dry cotton swab. Relayer the same colors. For the stem, burnish Jasmine and Light Umber. Wash with rubber cement thinner and a cotton swab. Burnish Jasmine, Raw Umber and Dark Brown (Verithin).

PALETTE
Body
- Spanish Orange
- Yellowed Orange
- Orange
- Pumpkin Orange
- Crimson Lake
 (Spectracolor)
- Crimson Red
- Pale Vermilion

Stem
- Jasmine
- Light Umber
- Dark Brown
 (Verithin)
- Raw Umber

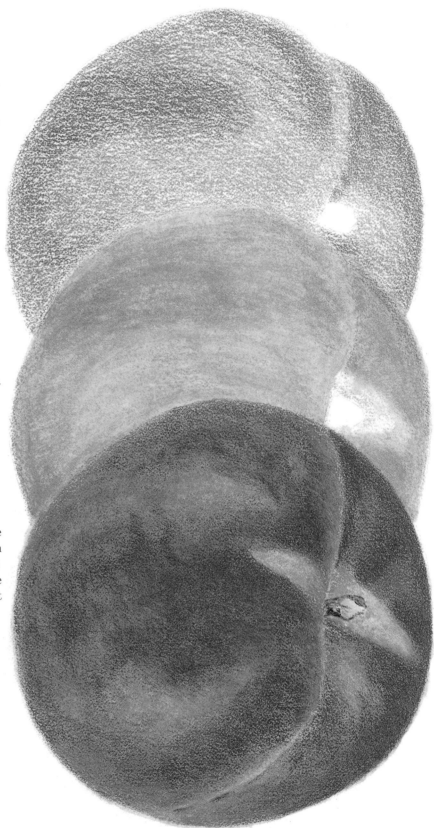

Painting Flowers in Acrylics

DEMONSTRATION: ACRYLIC

Using Acrylics Like Watercolor

BARBARA BUER

When Barbara Buer started using acrylics, she used tube colors and even heavy-bodied acrylics, both of which must be thinned out considerably to achieve watercolor consistency. She was introduced to inklike airbrush acrylics, which she used satisfactorily for a while, and then discovered Golden Fluid Acrylics, which she has used ever since.

MATERIALS

Here are the basic materials Buer uses:
- butcher's tray
- twelve Golden Fluid colors
- three Robert Simmons brushes (1-inch [25mm] white sable flat, no. 6 white sable round, no. 3 white sable pointed rigger)
- masking fluid
- empty baby food jar to contain large amounts of thinned paint for glazing
- reducing glass to relate specific portions of a painting to the whole
- strip of paper to check values
- short bristle brush to loosen and lift paint
- sponge to wipe wet paint from the butcher's tray palette
- paint scraper to remove dried paint from the tray

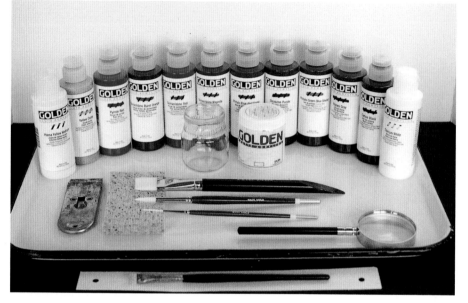

PALETTE
- Titanium White
- Hansa Yellow
- Yellow Oxide
- Quinacridone Burnt Orange
- Pyrrole Red
- Quinacridone Red
- Quinacridone Magenta
- Phthalo Blue
- Dioxazine Purple
- Phthalo Green
- Payne's Gray
- Carbon Black
- Burnt Umber

TIP Try using a butcher's tray as your palette. On this surface the acrylics, when dry, are easily removed by running the tray under warm water and wiping with a nylon-covered sponge. Be careful to not let the acrylic paint dry in a brush, however. It can be worked out using denatured alcohol, but it is much wiser to develop the habit of always rinsing the brush before placing it down.

POINSETTIA

1 PAINT BACKGROUND AND BEGIN POINSETTIA

Paint the background with approximately ten glazes of thin fluid acrylic paint using a large, flat, white sable brush, drying each layer before applying the next. The colors Buer used were Phthalo Green and Carbon Black. Paint the poinsettia petals with Hansa Yellow one at a time in order to preserve the edges and, while wet, use a paper towel to wipe out the highlights.

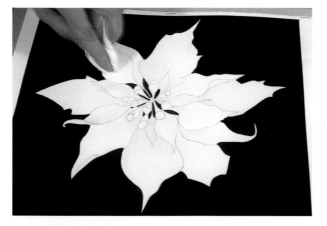

2 GLAZE ONE PETAL AT A TIME

Using a no. 6 round white sable brush, glaze each petal, one at a time, with various reds. Deepen the color at the base of the petals to allow the lower petals to recede and the upper ones to come forward.

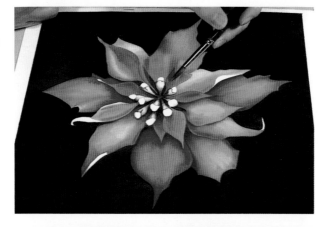

3 INTENSIFY BY GLAZING

Intensify the individual petals by adding additional galzes of color. While the paper is wet, use a knife to incise the surface, allowing the pigment to fall out of suspension into the incised line to form the veins in the petals. Use an ordinary kitchen paring knife or any hard-edged tool, such as a craft knife, the back end of a Skyscraper brush, a nail file, a nail, a pin, and so on.

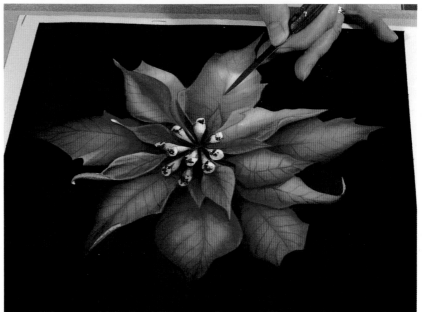

Light Subject on a Dramatic Dark Background

BARBARA BUER

Dark backgrounds are an intricate and important part of Barbara Buer's paintings, and she relies heavily on the two extremes of the value scale.

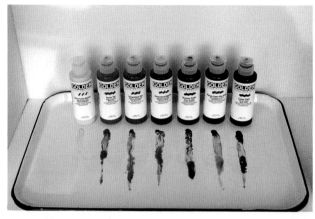

PALETTE
- Hansa Yellow
- Pyrrole Red
- Quinacridone Red
- Quinacridone Magenta
- Dioxazine Purple
- Phthalo Green
- Carbon Black

1 LAYER WASHES

First paint three magenta anemones, layering wash over wash, using Quinacridone Magenta and Quinacridone Red. In order to more easily create the very dark center carpel—which was layered with Carbon Black and the adjacent colors—mask the stamens with masking fluid.

TIP When selecting a masking fluid, choose only masking fluid that has no color added. Keep a small bottle of dishwashing liquid detergent among your art supplies. Dip your brush into the detergent, making sure all the brush hairs are completely covered with detergent before dipping into the masking liquid. Clean the brush in clean water when the fluid begins to show signs of building up, then start the whole process over. Masking fluid allowed to dry in a brush is impossible to remove. For that matter, it is difficult or impossible to remove masking fluid allowed to remain on the paper longer than two or three weeks.

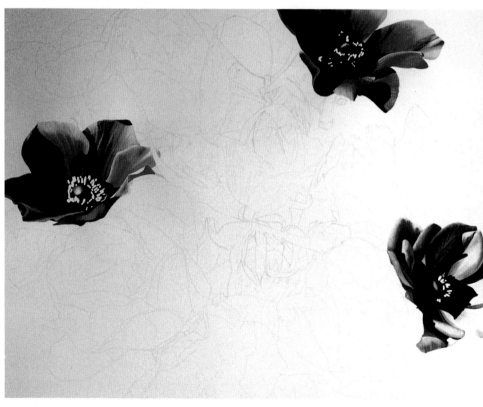

2 ADD PURPLE HUES
Paint the purple anemones in a similar way with Dioxazine Purple and Quinacridone Magenta.

3 PAINT ONE PETAL AT A TIME
The pink roses are partially painted using Quinacridone Red and Pyrrole Red. When painting complex flowers, it is best to attack each petal individually, starting with a transparent underpainting of the petal shape using a wash of the lightest value. Then, use additional glazes to model the shape of the petal. Approach it as if each petal is a painting itself. The secret is in constantly comparing the petals to be certain the color is harmonious. If necessary, apply a unifying glaze over all the petals. The pink roses were finished by using thin transparent Phthalo Green glazes to show the parts of the petals in shadow.

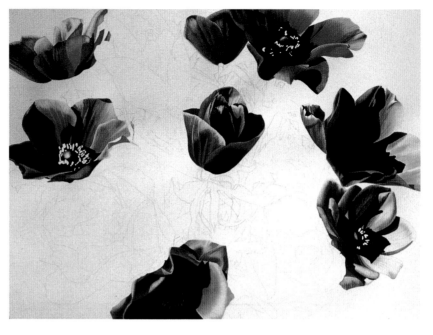

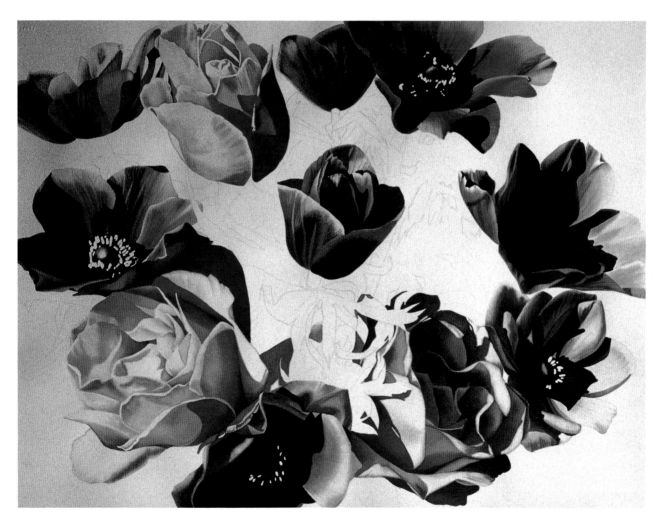

4 CREATE VEINS

Add the center foliage using Phthalo Green, Hansa Yellow and Carbon Black. Use a kitchen knife to incise the veins in the foliage. Do this by painting the leaf and, while it is wet, cutting into the surface of the paper. This causes some of the pigment to fall out of suspension and into the incised lines.

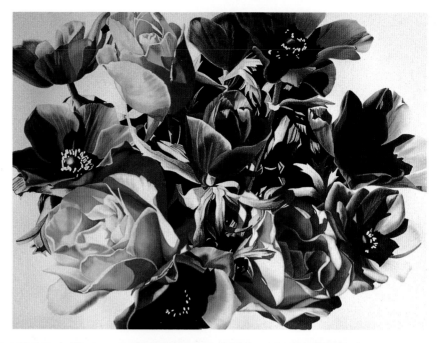

DETAIL OF CENTER PURPLE ANEMONE
The veins in the center flower were created by incising the paper with a knife while the glaze was still wet. You can also see incised lines on the leaves.

TIP In order to achieve a dark area with acrylics in a watercolor manner, it is necessary to build up the color by applying many glazes. If the paint is applied in a heavy layer, a shiny surface will be produced, which is undesirable when painting in a transparent watercolor manner.

BARBARA BUER
Anemones & Roses
Acrylic, 22"×30" (56cm×76cm)

5 PAINT THE BACKGROUND

Paint the dark background with a 1-inch (25mm) flat white sable brush, applying numerous glazes of a thin mixture of Carbon Black and Dioxazine Purple.

TIP Although we all would love to never make mistakes, there are times when a judicious repair can save hours of work. To remove a buildup of acrylic paint, apply denatured alcohol with a brush and wipe up the softened paint with a paper towel. This will not remove the stain from the paper but will reduce it greatly. In order to repaint such an area in a watercolor manner, apply thin glazes of Golden Mat Acrylic Titanium White until the stain is obliterated. The matte finish allows future repair glazes to adhere better than if regular glossy acrylic is used to bring the paper back to white. If your paper is not as white as the Titanium White acrylic, you may want to add a drop of color to the Titanium White in order to more closely match the color of the paper. For instance, if using Arches paper, add a touch of Yellow Oxide to the Titanium White because the Arches paper is a much warmer color than the Titanium White acrylic paint.

Titanium White as a Mask

To keep a pattern under layers of acrylic glazes, use Titanium White. Here (at right), Titanium White was painted over a tracing of a stencil. Using a 1-inch (25mm) flat white sable brush, paint a wash over the entire piece of paper. Allow it to dry, then place a strip of masking tape over the first inch at the top of the paper. Apply another glaze over the rest of the paper. Once dry, add another inch of masking tape and apply another glaze over the rest of the paper. Continue this process until you reach the bottom of the paper. The Titanium White acts as a partial mask but is never entirely obliterated, even under ten glazes. Barbara Buer often uses this technique when painting background draperies, such as in the following paintings.

below
BARBARA BUER
Island Still Life
Acrylic, 22" × 30" (56cm × 76cm)

Buer used Titanium White as a mask in the dark background drapery to paint a simple pattern that shows under both the highlighted part of the drape and the part in shadow.

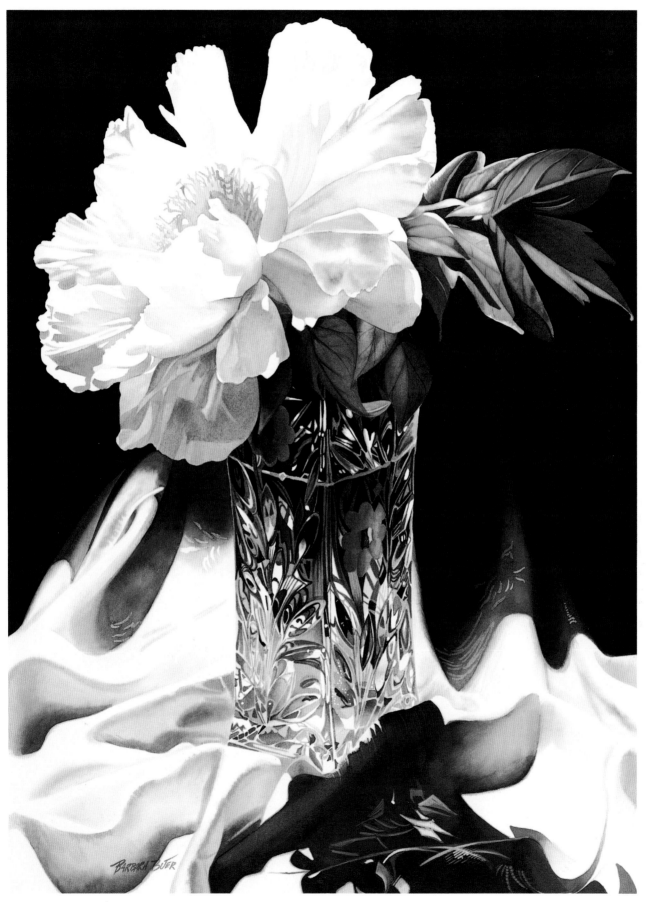

BARBARA BUER
White Peony
Acrylic, 22″×30″ (56cm×76cm)

Dark Subject on a Light Background

Underpaintings, or the first layer of paint applied to your painting, later to be covered with additional layers of paint, is extremely helpful in defining the complex shapes caused by closely arranged flowers. Rather than painting one thick coat, layer many thin layers of acrylic of a watercolor consistency. Thin glazes of Golden Fluid Acrylics are easily overpainted because of their permanence. Overpainting with watercolors disturbs underlying washes and results in muddy passsages.

Build color by applying many thinned fluid acrylic glazes. For *Magenta Petunias*, the artist used Quinacridone Magenta, Pyrrole Red, Quinacridone Red, Phthalo Green and Carbon Black.

Use masking fluid to mask out areas of reflected light on the bottom of the vase as well as the petals and stems hanging over the vase. For this painting, the artist applied numerous glazes of Dioxazine Purple and Carbon Black with a 1-inch (25mm) white sable flat brush.

After removing the mask, dampen the reflected light areas and soften the edges using Dioxazine Purple and Carbon Black again. For the window frame, use Burnt Umber and Carbon Black with a touch of Dioxazine Purple.

Paint the foot of the dish with the surrounding colors, and wash in a light underpainting to suggest the background foliage outside the window. Paint the darker background window foliage with numerous glazes of Phthalo Green, Carbon Black and Dioxazine Purple, then glaze over with Iridescent Silver to soften the deep color and suggest a window glass.

BARBARA BUER
Magenta Petunias
Acrylic, 22"×30" (56cm×76cm)

right
BARBARA BUER
Red Roses, Brass Container
Acrylic, 30"×22" (76cm×56cm)

BARBARA BUER
Gerbera Daisy
Acrylic, 22"×30" (56cm×76cm)

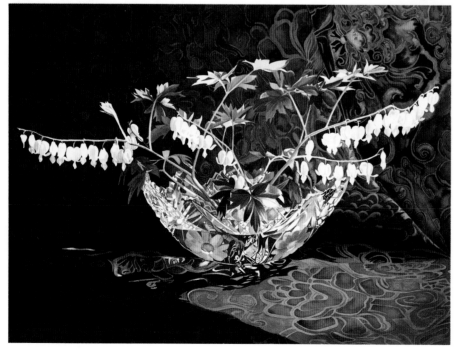

right
BARBARA BUER
Red All Over
Acrylic, 48"×36" (122cm×91cm)

BARBARA BUER
White Bleeding Hearts
Acrylic, 22"×30" (56cm×76cm)

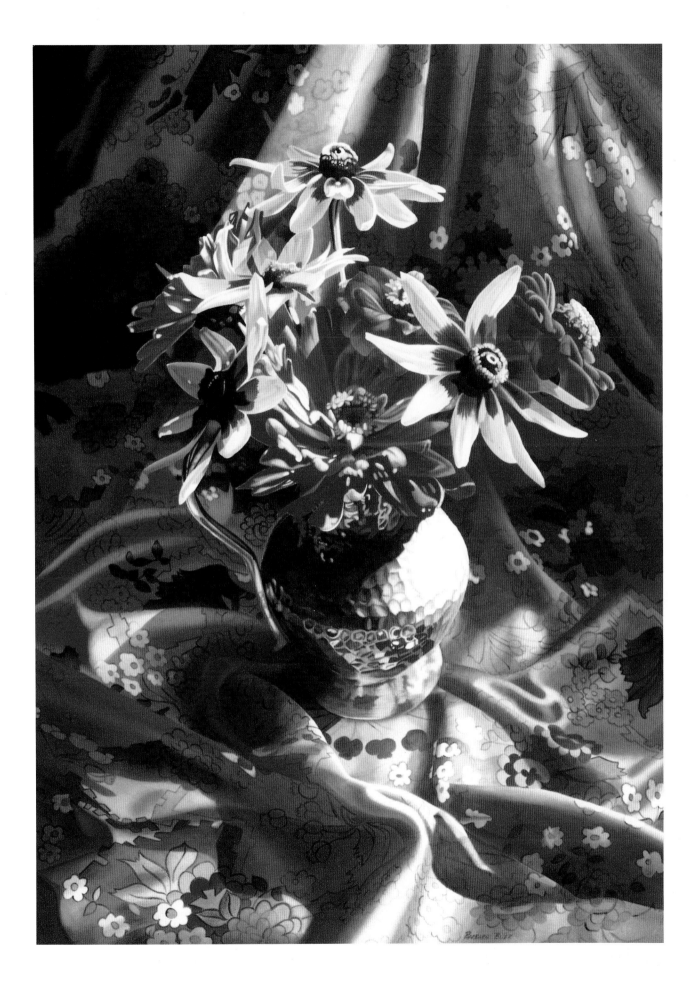

Creating Unexpected Edges With Negative Painting

WILLIAM HOOK

Reference Photo

1 GET STARTED
The process for developing a still life is the same as for a landscape—sketch it first.

2 BEGIN WITH LIGHTER FLOWERS
Sunflowers are the primary subject in this scene, so begin with them. Thin and paint Cadmium Yellow Medium in a way to let translucency work for you. Light will pass through the thinned pigment and bounce back to create the effect of brightness. Do not use an acrylic medium glaze or you will end up with the glaze in the rest of the painting. (Glazing creates a nice glossy surface.)

3 BLOCK IN DARKER COLORS

Block in the darker colors after the light colors in order to help shape the flowers themselves. Use Permanent Green Light, Phthalocyanine Green, Yellow Oxide and Cadmium Yellow Medium to make the foliage.

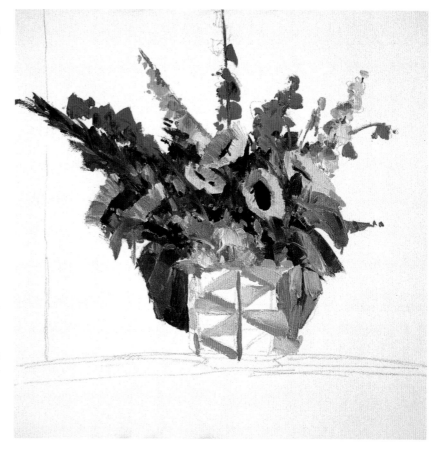

below

DETAIL

Much of the color mixing is done on the canvas. Rely on wet paint to promote natural results. By "natural," the artist means that foliage has so much detail he prefers to see the pigments swirl together and blend freely without brushing out such spontaneous happenings. Experience has turned what was once unexpected luck into controlled and expected results.

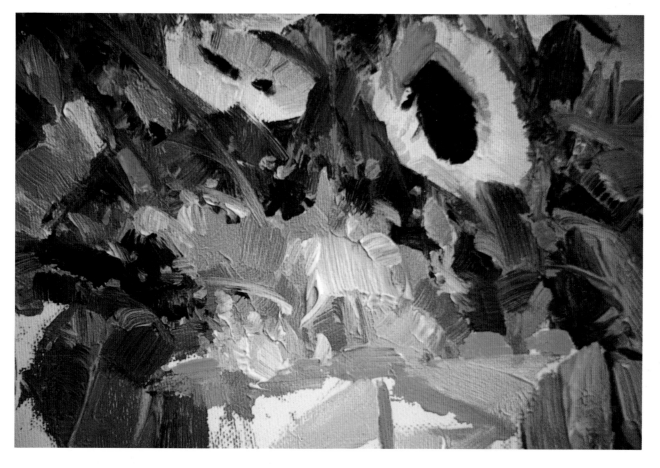

4 COMPLETE THE STILL LIFE

These details will demonstrate the process William Hook calls "negative painting." It is his belief that the viewer responds to the unexpected with more excitement than when the expected is provided. This is the reason for painting the background after the foreground.

below
DETAIL

This detail shows you how the vase was painted. To create consistency throughout the painting, the brushwork is similar to that in the flowers. Paint quickly, to blend wet paint on the support. The shapes in the vase utilize negative painting just as in the background. Define narrow bands of color by painting in the larger triangular shapes afterward. Highlight the natural blending and swirls created on the canvas with white. Pick obvious spots where the reflections are brightest and add a quick stroke of white with the corner of a no. 8 brush.

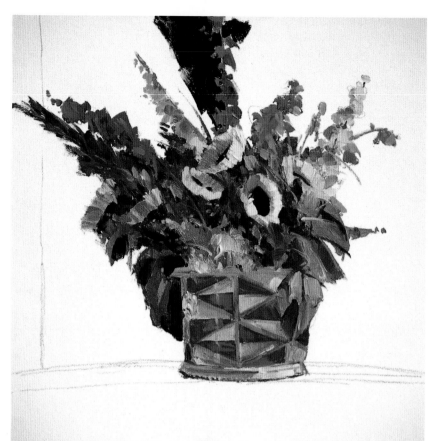

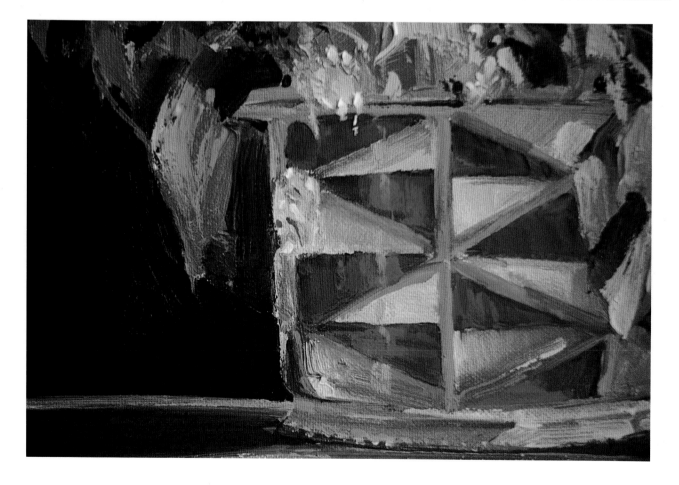

5 DETAIL: ADD FINISHING TOUCHES

The light source is to the right of the scene, so paint in the background color (purple and Naphthol Crimson) up to the edges of the flowers' left sides. Leave parts of the white canvas showing on the right sides of the flowers rather than using predictable brushstrokes to add highlights. The brushstrokes remain obvious in the background. The ambiguity of the background is enhanced by this technique, which is also harmonious with the brushwork in the flowers and vase. Negative painting allows you to make very quick and deliberate strokes, leaving the viewer unaware that one brush was used to paint the entire painting.

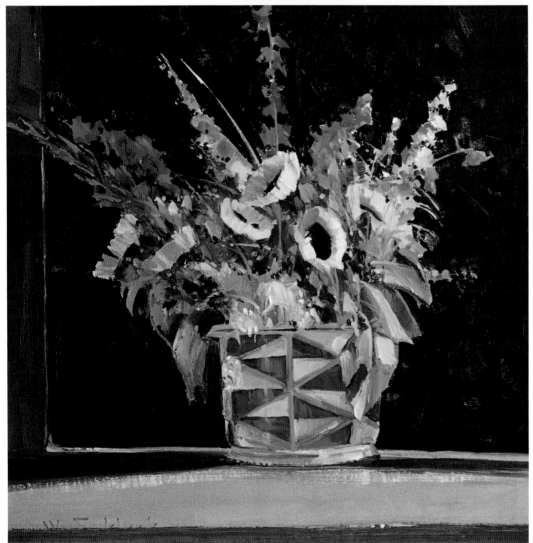

WILLIAM HOOK
Some Flowers
Acrylic, 18" × 18" (46cm × 46cm)

Pastel Painting Techniques

Because of the vast array of ways to use pastel, it is a medium suited equally well for both beginning and accomplished artists. Pastels are dry and direct, requiring no mixing medium. The colors do not sink in as oils nor fade as with watercolor, and they are durable and permanent because they are pure pigments with some inert binder. We have in pastels the best of all possible worlds—speed, directness of execution, permanence and brilliance of color.

Hard vs. Soft Pastels

Pastels are available in several forms: pencils, hard sticks, soft sticks. The hardest pastels are generally *pastel pencils*. With their hard pigment and thin points, these allow the greatest control, so they are excellent for drawing. The width of the line can be varied by using a sharp or dull point or the side of the point.

Hard pastels, like pastel pencils, permit great control. They are good for fine lines and details as well as applying thin layers of colored strokes.

Soft pastels cover large areas quickly, blend easily and, with a delicate touch, can be used for detail. Because they go on so easily and tend to crumble with excess pressure, however, each stick is used up quickly. They also tend to fill the pores of the surface, resisting application of hard pastels and hiding the paper texture that many artists want exposed. Just as the rule in oils is fat over lean, so the rule with pastels is soft over hard.

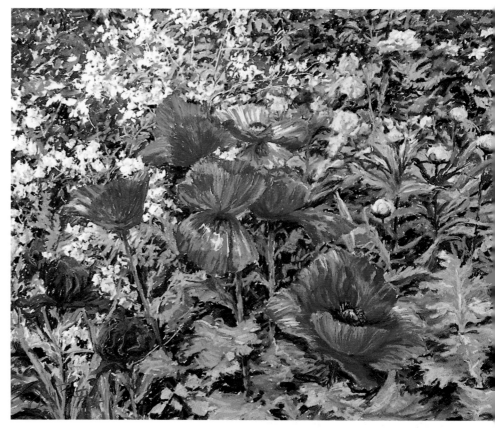

JUDY PELT
Poppies at Giverny
Pastel, 24"×30" (61cm×76cm)

TIP Many pastel artists begin their paintings with an *underpainting* in another medium. Before applying your first stroke of pastel, cover the paper or board with watercolor, acrylic or oil, and let dry.

The underpainting can be as simple as a solid wash of one color or as complex as a finished painting. Its purpose is to provide tone, delineation, value or local color.

Strokes

In pastel, individual strokes of color are used for more than just covering the surface. They can also provide texture, show depth and volume, outline contours and establish details. As with brushstrokes, each pastel has its own character. It can be short, long, fat, thin, curved or straight. (The hardness or softness of each pastel stick will vary the character of the stroke.) To develop a repertoire of strokes, try making different kinds of marks with your pastels.

Thin, precise lines and details can be created by using pastel pencils or sharpened sticks of pastel. Turning a pastel on its side will produce wide strokes for covering large areas quickly. Repeated directional strokes, as in crosshatching, can be used to establish surface texture, depth, shape and value. When strokes are smoothed out with fingers or a cloth, transparent layers of color can be developed. Pastels can be used like watercolor or thinned oil, built up gradually with layers of glazes. Large areas of solid color can also be created by drawing wide strokes with the side of a pastel stick or by blending thin strokes. A much more interesting effect, resulting in not only flat color but also an interesting surface texture, can be created by using broken color.

Crosshatching, or *feathering*, involves layering lines. There are basically three types of crosshatching. The first sets down rows of linear strokes all in the same direction. Cover those strokes with more strokes in the same direction, continuing the process until you have the desired intensity of color. The second, or more traditional type of crosshatching, is to draw many straight strokes in the same direction (for example, vertically). Next, cover those parallel strokes in another direction (horizontally). Add more lines in another direction (diagonally) and so on. This will create a geometric, woven-looking pattern. And third is the layering of ran-

JUDY PELT
Flowers of the Field
Pastel, 22" × 28" (56cm × 71cm)

Pelt's subtle combination of abstract patterns and impressionistic subject matter illustrates skillful handling of the medium.

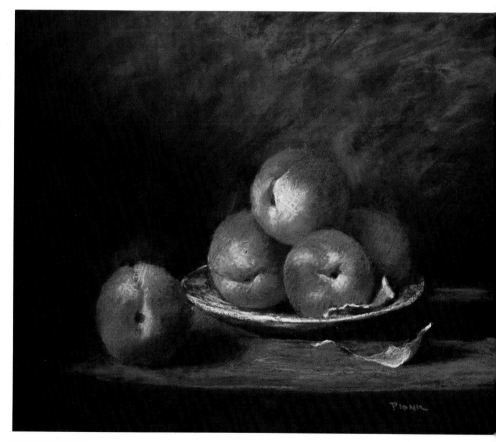

RICHARD PIONK
Peaches
Pastel, 11" × 12" (28cm × 30cm)

Richard Pionk's paintings are a combination of distinct and blended strokes. Here, the combination of hard and soft edges creates the illusion of space. The edges and details closest to the viewer are sharp; those that are further away are blended.

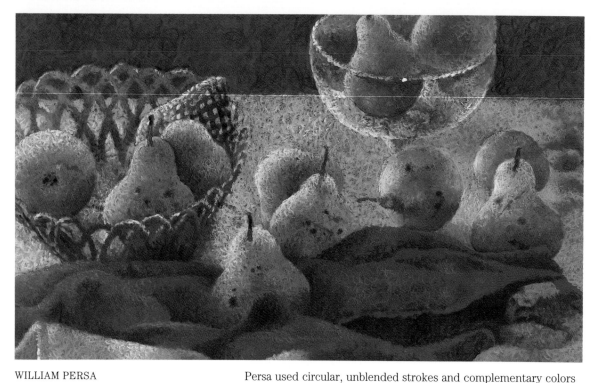

WILLIAM PERSA
A Symphony of Pears
Pastel, 7½" × 11½" (19cm × 29cm)

Persa used circular, unblended strokes and complementary colors to create the strong visual effect seen here.

dom or scribbled strokes. Cover the area with one layer of random strokes. Add another layer and so on. This looser type of crosshatching will create strokes with a more organic appearance.

The use of *glazing* with pastels is especially successful when *blending* colors. Because pastels are a dry, solid medium, they cannot be blended into new colors on the palette. Existing colors must be blended or mixed within the painting, creating new colors by rubbing strokes together, overlaying existing colors or by merely placing various colored strokes next to each other. This last technique creates a vibrant surface that, when seen from a distance, is blended into a solid color by the eye.

Soft pastels blend more easily than hard. The amount of pressure will also affect blending. Very light strokes can lift right off the paper; very heavy strokes can be so deeply embedded in the paper that the pigment will hardly move. Blending will always lift off some of the pigment, so the best way to achieve very

intense colors is to apply many layers of blended strokes. Stroke on the pastel, rub it in, shake off the excess dust, then repeat the process until you get the desired color. (Fixative is a useful tool when building up blended layers. Simply add color, blend, spray and repeat.)

The nature of your strokes will affect the sense of your painting. Keep the following suggestions in mind:

• To paint a three-dimensional form, rounded strokes will reinforce the illusion of roundness, while straight strokes will flatten the image out.

• To create a sense of depth and enhance the illusion of space, use strong, definite strokes in the foreground and softer, less defined strokes in the distance.

• Use less obvious strokes to create areas of very bright light or very deep shadow where detail is not easily seen.

• To make a focal point more powerful, render it with strong, definite strokes and surround it with softer ones.

• If all the strokes are the same length or direction, the painting will

look very mechanical.

• A sense of chaos will result if every single stroke is different from the others. For the most interesting surface texture, vary the strokes in a limited way, repeating each type enough to provide a feeling of consistency.

• Finally, if the strokes themselves ever become the most dominant element in the painting, they will detract from the impact of the painting as a whole. It is important to keep in mind that the character of the strokes will affect the finished art. Never become so involved with the individual strokes that you lose touch with the total painting.

TIP Blending complementaries will always result in grayed colors, but these are important to include in a painting to provide a counterpoint to the dramatic pure colors. Blending any color with browns or black will deaden the original color, so be careful with these.

Details and Edges

There are two approaches to adding detail to pastel paintings. The first is to indicate basic details in the initial drawing or underpainting and include them in every subsequent stage of the painting. Here, the initial drawing must be finely developed, leaving nothing to chance. This requires planning and control of the medium. Most of the work should be done in medium to hard pastels so the underlying contours are not obscured or distorted. Often the details need to be reinforced or even redrawn as the painting proceeds.

The other approach allows for more flexibility and experimentation. First the largest shapes are laid in. Next, the contours are refined and the smaller shapes are developed. Finally, when everything else has been established, the smallest details are placed.

In planning for detail in your composition, be aware of the hardness of the pastels. If you want to use pastel pencils or sharpened hard pastels for drawing details, do not build up thick layers of soft pastel first. The hard pastel will not adhere well to the very soft pigment. You can spray fixative for a more receptive surface, but that may change the texture and value of the colors.

HARD VS. SOFT EDGES

The easiest way to make a hard edge is to draw a single, crisp line for the contour, then fill in that shape with color. For the sharpest line possible, use a pastel pencil or hard pastel stick sharpened to a point and use against a straightedge.

Sharp outlines can also be created by using paper cutouts. Suppose you are painting a building in the foreground that calls for crisp edges. Begin by laying in and blending the background, spraying it lightly with fixative. Cut out a piece of fairly sturdy paper in the shape of the negative space surrounding the building. Lay the cutout on that shape and hold it

JANE LUND
Gourds and Onions
Pastel, 14" × 15½" (36cm × 39cm)

Note the fine detail used in this piece, from the peeling onion skins and bumps on the gourds' surfaces, to the woodgrain of the box.

in place while you paint the building. When finished, lift the cutout and the building will have sharp edges.

For the softest edge, move your blending tool in a motion perpendicular to the edge, or, using a hard pastel, add strokes on top of your edge in a different direction.

When deciding whether to use hard or soft edges, keep the following rules in mind.

• To create the illusion of three-dimensional space, place the harder edges in the foreground. As objects recede in the distance, use less distinct outlines.

• If you are painting a flat circle, mark the entire circumference with a distinct edge. To make the same circular shape look like a ball, soften the edges.

• Using hard edges or details throughout an entire piece tends to flatten out the image. Use outlines sparingly or draw them with broken lines, allowing some colors to flow into each other.

• To show edges without using outlines, simply butt one color up against another. The contrast between the two colors will create the sense of a line where the shapes join.

• Sharp edges add emphasis. If most of the painting is done using blended strokes, the few areas with distinct edges will become focal points. With pastels, you can be as precise or as loose with details and edges as you choose, but be deliberate.

Composition

Create beautiful color, interesting texture, vital strokes and dramatic values and your painting will still not work without good composition. No matter how strong each part is, they must all fit together.

There are two different approaches for developing a composition. The first is to draw all the contours of your design. Once you have rendered all the outlines, the appropriate values and colors can be placed within the indicated spaces.

The second method is to avoid lines and work exclusively with shapes. Rather than seeing and drawing the outside of an object, learn to see and draw abstract forms. Your painting might first look like three or four large shapes. However, as you refine your painting, these shapes will break down into smaller shapes.

You can also combine these two methods. Consider starting your painting with a quick gesture drawing. Then, using that drawing as a guide, block in major shapes, not concerning yourself with exact outlines. As you paint, refine shape and line as necessary. By starting with a basic plan for the organization of shapes, values and colors, your painting will develop more smoothly.

Consider the following compositional elements before starting.

• To create a basic geometric pattern, a triangle for instance, large shapes or focal points will help make the total image appear unified.

• A single focal point will catch the eye, while secondary focal points will move the eye around the painting.

• Placing all the darks in one area will make that section too heavy, and all the lights in one area will draw the eye away from the rest of the painting. Try to create a balance between your lights and darks.

• Pastel paintings can become very chaotic because of the vast selection of colors. Preplanning will help you simplify for the strongest impact.

• Regardless of the subject, no area of the painting should be left without visual interest. Large, flat areas can be dead holes in a composition. To break up large shapes, energize them with subtle value and color changes. To simplify a scene with a profusion of small shapes and details, add a few main shapes.

A basic composition sketch.

ELSIE DINSMORE POPKIN
Reynolda Garden—
Marigolds and Celosia
Pastel, 30″ × 38″
(76cm × 97cm)

Basic composition sketches, such as the one above, can be used to create simple designs from which elaborate finished pieces are made. After blocking in the large shapes, refine and add details as you paint.

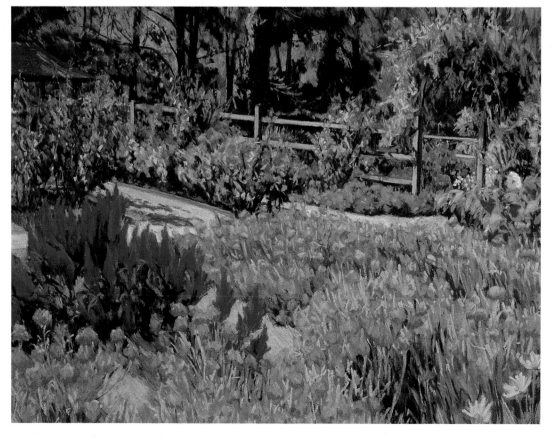

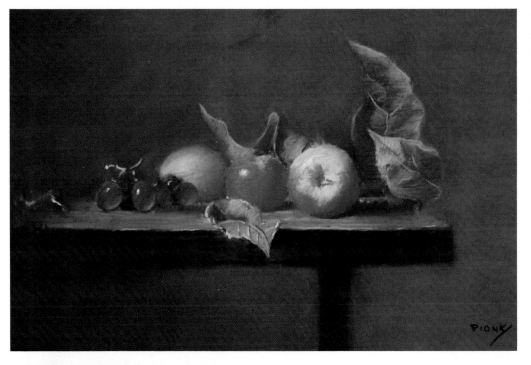

RICHARD PIONK
Apples on Table
Pastel, 9″×15″ (23cm×38cm)

This simple composition focuses on the intrinsic beauty of each piece of fruit.

TIP Remember, it's good practice to use the hardest pastels to lay in the basic colors because they are easily covered with softer pastels.

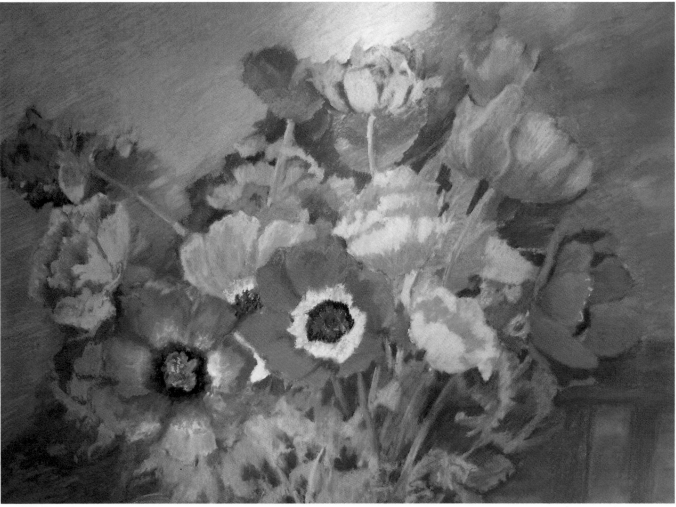

MADLYN-ANN C. WOOLWICH
Rhinebeck Anemones
Pastel, 18″×24″ (46cm×61cm)

Compare the similarities and differences between this composition and *Reynolda Gardens*. What are the focal points of each? How do the balance of lights and darks, light and shadow, negative and positive shapes, and value changes compare? Note the fine detail of one and the soft blending of the other. What makes each composition successful?

Painting Indoors

RICHARD PIONK

Richard Pionk prefers to work exclusively in his studio where he sets up and paints his beautiful still lifes. Using the traditional method of setting up the subject and working from life, Pionk has maximum control of the choice of objects, placement and lighting.

Pionk chose his studio because of the north window, which provides a source of unchanging light. By blocking off the lower portion of the window, the light comes through in a downward direction as if it were coming from a skylight.

Pionk is especially interested in the effects of light. In *chiaroscuro painting*, or a painting that focuses on the interplay of light and shadow, the eye follows the light, moving from one section to another, and the shadows structure the painting. As seen in the artist's finished piece, *Melon and Grapes* (page 88), the light comes in from the left, moving toward the focal point. The background is dark and the light on the objects gradually becomes brighter as it moves to the right.

Pionk's interest in light is one of the reasons his paintings have a classical look. Another is his method of working from value to color. Working on a variety of surfaces, he begins each painting with a charcoal drawing to place shapes and values, then he moves on to blocking in the shapes of colors.

Pionk builds up color with strokes of French pastels, which he prefers for their softness and brilliance of color. In between workings he sprays a light layer of fixative, holding the can approximately 12 inches from the surface.

1 START WITH A GESTURE SKETCH
Start with a triangle and a fast gesture drawing, using medium vine charcoal, and develop objects slightly off center.

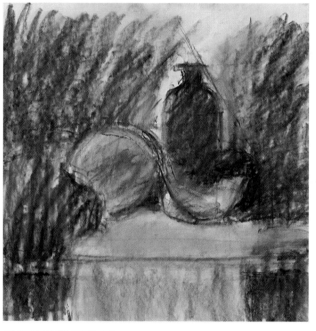

2 BLOCK IN OBJECTS
Block in and correct the drawing with charcoal, wiping out lines and smoothing areas with your finger. Your main interest here should be the large shapes; give no thought to detail at this stage.

3 BLOCK IN BASIC COLORS
Starting with hard pastels, block in the basic colors. Draw the strokes from left to right, reinforcing the direction of light.

4 FILL IN THE LARGE SHAPES
Continue to fill in the large shapes with hard pastels. Use the sides of the pastels, applying light pressure, and work from dark to medium to light.

DETAIL
Merely suggest some shapes while carefully rendering others. Here, the grapes that are closer and in more light are more precise.

DETAIL
Here, softer edges are created using rougher strokes or by slightly blending strokes with a finger.

TIP Too much fixative spray can darken pastels. To deliberately darken colors and add drama to your painting, mask the areas surrounding the colors to be darkened, then spray.

5 SHARPEN EDGES

Begin to pull out more objects by basic shape and additional color, sharpening some edges for added clarity. Some edges should be hard and others soft depending on the location and lighting.

6 ADD FINISHING TOUCHES

Give the surface a light spray of fixative and switch to soft pastels. Add only necessary details, keeping the focal point in mind (the large melon slice). The dark grapes and melon slice act as a frame to pull the eye to the lighter, larger melon. For the background, create a rich balance of shape and color. And for the individual grapes, add detail to emphasize their closeness. Finally, apply a light spray of fixative.

RICHARD PIONK
Melon and Grapes
Pastel, 15"×15" (38cm×38cm)

Painting Outdoors

ELSIE DINSMORE POPKIN

Elsie Dinsmore Popkin worked al-most exclusively with the figure, using models, until she received an in-vitation to participate in a landscape show. By the time she finished, she was hooked on landscape painting.

Popkin relishes the challenge of searching out compositions in nature after years of arranging models and props in the studio. Sunlight and shad-ows in living landscapes create colors much more vivid and subtle than that of a studio. Popkin discovered a total immersion in the lush landscape; never having to stop for a model to rest freed her to work more intensely and spon-taneously.

Popkin has developed the materi-als, tools and painting techniques to take full advantage of the extensive range of outdoor subjects. All her painting equipment is portable. She simply finds a subject, sets up her stu-dio and starts painting.

She works on site to capture the light and colors of the landscape, with an immediacy and intensity necessary when racing the sun and seasons to completion. Popkin tries to capture and express the essence of the landscape she's painting. She wants the viewer to experience the same deep satisfaction she feels, and hopes that her pastels will open the viewer's eyes to his own surroundings, helping him to see and rejoice in the forms, colors and beauty of the world around him.

This photo of the subject was taken on the first day of painting. By the time Popkin finished, the spring foliage was much more lush.

1 START WITH A CHARCOAL SKETCH
Begin with a charcoal sketch on sturdy Rives BFK paper prepared with an acrylic-marble dust wash. Indicate the placement of the path, trees and bushes.

2 BLOCK IN THE LARGE SHAPES

With your hardest pastels, block in the large shapes that organize the composition. From the start, use a variety of strokes, keeping them larger than those that will finish this piece.

3 LOOK FOR PATTERNS IN THE SHAPES

Work over the entire surface, painting most densely in the background where the darkest values are. Look for patterns in the shapes: the parallel lines of trees, the diagonal rows of pink flowers in the lower left.

4 DEVELOP THE FLOWERS

Develop the colors and textures of the flowers. The pattern of sunlight should begin to show. Leave the strokes unblended, as blending will blur and dull the colors.

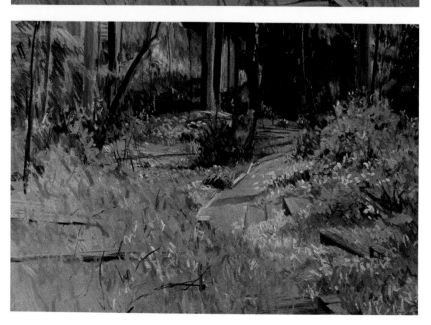

ELSIE DINSMORE POPKIN
Pat's Garden With Carolina Silverbells
Pastel, 22″×30″ (56cm×76cm)

5 FINISH THE PAINTING

Now that the darks have been established, add details to the surface. Keep a can of fixative spray handy. For more painterly strokes, work color into wet fixative. Your painting will be finished when there is equal attention to detail and brilliance of color throughout.

Painting Flowers and Fruit in Oils

DEMONSTRATION: OILS

Mapping Large and Small Shapes

KEVIN D. MACPHERSON

A good painting has unity and variety. Variety adds interest. Design your shapes to add variety. Create each major shape differently. Think of your painting as a mosaic of large and small interlocking shapes. Paint shapes, not things. The correct shapes and colors in the right places create realistic images.

1 ARRANGE THE SUNFLOWERS
A strong spotlight off to the right illumintes silk flowers, an old painting hung sideways and dried weeds. The still life is arranged on a sculpture stand that can be raised or lowered as desired.

TIP When all your practicing comes together and your painting abilities are on target, a painting often paints itself; that is, you work intuitively, your painting flowing almost subconsciously. When that happens, sit back and be thankful. Simply stated: Trust your intuition.

2 DRAW THE MAP
Draw in shapes using a color suggested by the overall arrangement that will not overpower the final colors. This drawing is mainly a map that will be covered over later. Some subjects require very little preliminary drawing, while others need a more careful layout to avoid trouble later.

3 CONSTRUCT THE BIG PICTURE

When laying in the initial shapes and colors, try to respond quickly and intuitively, trusting your first impression. The color notes in the background painting have a richness and spontaneity that barely need adjusting. The background color is basically a solid tone with variation added from the start.

TIP To eliminate unnecessary details, try squinting.

4 BREAK DOWN THE LARGER SHAPES

After the initial block-in, step back. Compare your subject with your canvas. What is the most obvious area in need of correction? How is your painting different from the subject? How can you break down the initial shapes further? Perhaps a shape's color goes gradually from warmer to cooler, or from lighter to darker. Move around the canvas without lingering too long on one shape. Make subtle adjustments to the original block-in, refining the shapes without destroying the general contrast and harmonies already established. Establish visual dialogues, such as in the background above. The lower-right sunflower reflects yellow light into the background, while the vase reflects a purple glow.

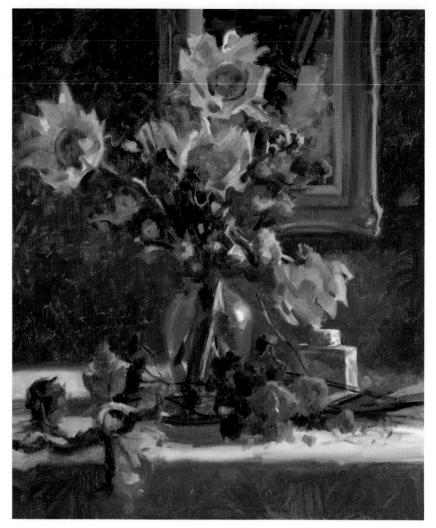

TIP We imagine everything is in focus because we constantly shift our eyes. In reality, when we focus on a subject or area, we see the rest with our peripheral vision. So not everything needs to have equal emphasis in your painting, but you should emphasize your subject.

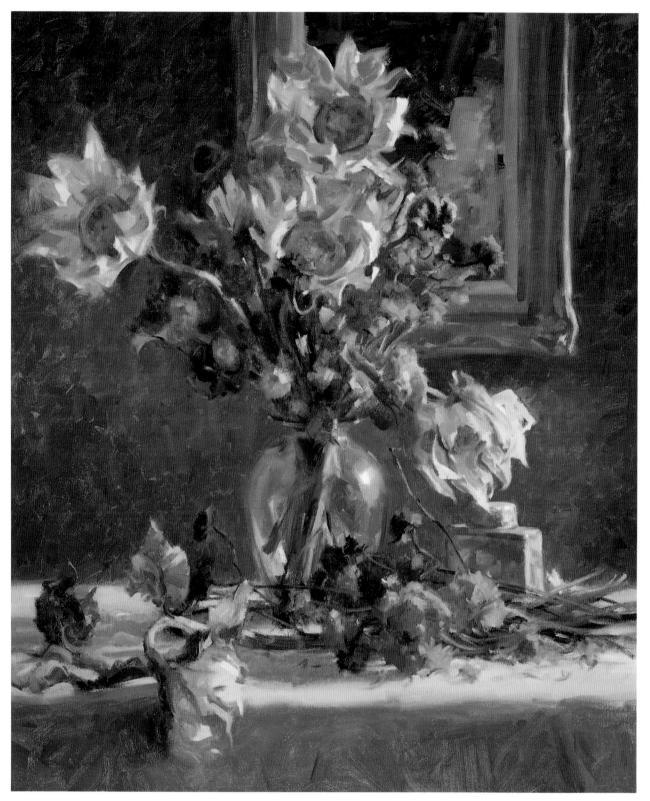

KEVIN D. MACPHERSON
Sunflowers
Oils, 36″×30″ (91cm×76cm)

5 SUGGEST DETAIL

Continue to break down the shapes into suggestions of detail, periodically stepping back or viewing the piece in a mirror. Don't overwork the painting. When there are no more adjustments or corrections needed, you are done.

Painting Rich Color In a Still Life

PAUL STRISIK

1 BEGIN WITH THE SETUP
To create a rich, colorful painting, choose colorful fruits and use neutral and softer colors for the rest of the composition.

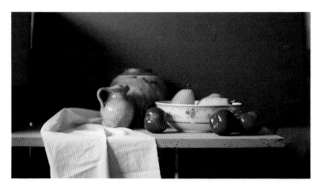

2 SKETCH WITH CHARCOAL
Start with a charcoal sketch in this case to be certain of your composition.

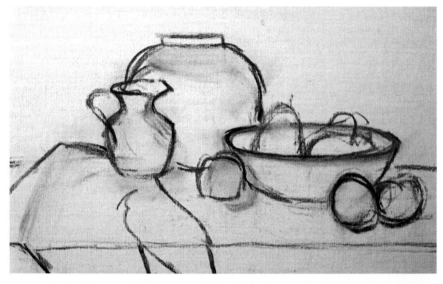

3 LAY IN INITIAL COLORS
Lay in approximate colors thinly so things can be easily wiped out and rearranged. Lay in a warm background using Burnt Sienna and Mars Black, indicating that the source of light is at the left.

4 CREATE LUMINOUS LIGHT

Paint the fruit with indications of the shadow sides. Small, well-placed reflections on the shadow sides help convey a luminous light effect. Use Ultramarine for the white cloth, Raw Sienna for the shadows and a touch of the same for the tone of the cloth, leaving a purer white for the few highlights.

PAUL STRISIK
Pears 'n' Plums
Oils, 12" × 20" (30cm × 51cm)

5 ADD DETAIL

In the final session, add the design on the bowl and the leaves, which loosen up the otherwise rigid forms of the general composition.

Still lifes are a refreshing change from outdoor subjects. The principles of painting, however, remain the same—whatever the subject or location may be.

An Outdoor Floral in Bright Sunlight

HOWARD CARR

These freshly picked cosmos from the garden were haphazardly placed in an antique ceramic pot to convey the feeling of spontaneity. The lighting is bright but not too harsh. This clear sparkling light shows off the brilliant pinks of the flowers while creating vibrant shadows filled with colorful bounce, or reflected light. Compare the reference photo to the final painting (page 102) to see how the artist softened and warmed the white light in the photo. Softening the light gives more color to the flowers and reflections and allows for more value changes in the background. Softening the light also produces a cheerful mood.

Reference Photo

1 TONE THE CANVAS
Tone the canvas with some of the general colors you want to use in the painting. A towel dampened with mineral spirits helps move the paint around.

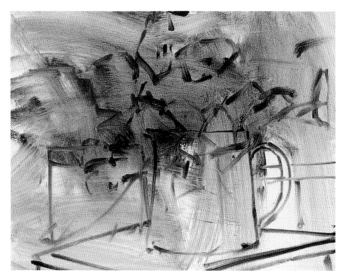

2 DRAW OBJECTS
With a no. 3 filbert, line in the objects to be painted . . .

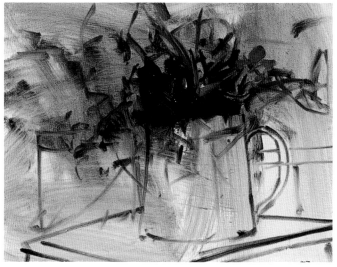

. . . and begin blocking in the dark foliage area with Sap Green and Ultramarine Blue.

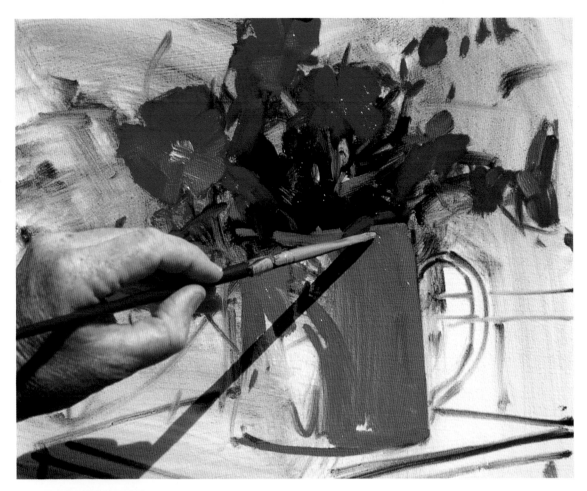

Block in the basic flower shapes and paint the shadow forms on the pot. Keep the block-in loose by using a bigger brush (no. 8) and a wispy, flowing movement. You want to convey a mood of just-put-there flowers, not a stiff, designed arrangement.

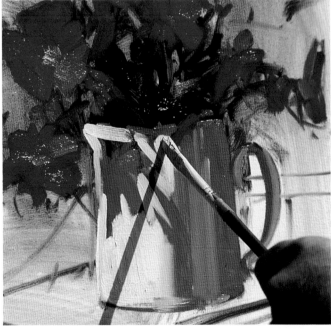

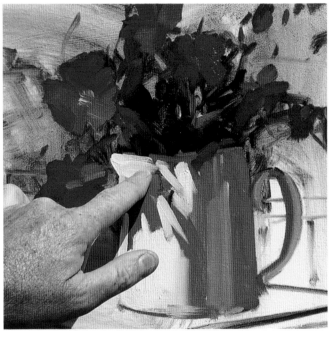

4 SHAPE THE SHADOWS

Use white with a touch of Cadmium Orange and work it into the flower shadows on the pot. Changing the original pot color gives a warmer and more comfortable mood to the painting. Define the tip of the pot and give the shadows contour to describe the rounded shape of the pot.

Your finger makes a great blending tool.

5 FINISH THE POT
Adding the blue striping on the pot helps show its contour. In this picture, some of the background has been blocked in.

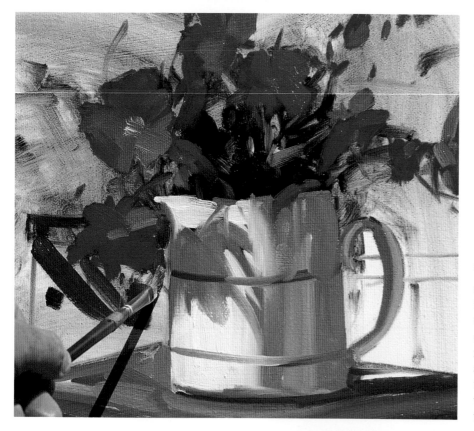

6 GET NEGATIVE
To carve out the negative background areas, use a nice variety of darks and lights to balance the piece. Be careful not to up-stage your main subject: the pot and flowers. Using subtle complements, go from midtones on the left to darks on the right, and to complementary (greenish) lights on the top. These colors push the flowers forward while also giving them an environment to hold onto.

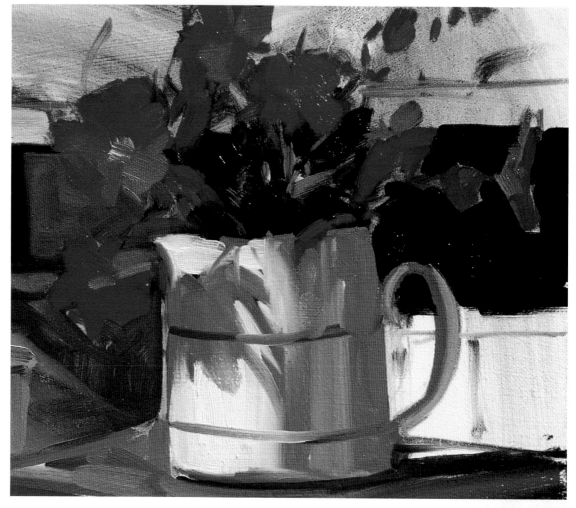

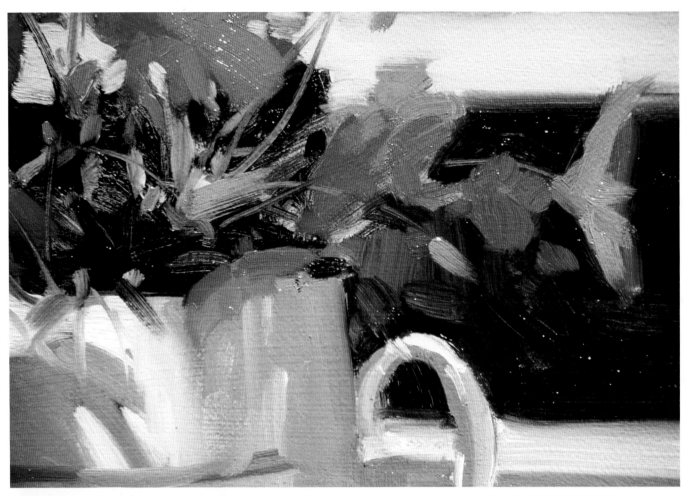

7 DETAIL: ADD HIGHLIGHTS

Put some light values on the flowers and foliage to give them a more recognizable shape. The flower color is Permanent Rose, Alizarin Crimson and Cadmium Red Light. To highlight, use this same mixture, adding white and a touch of Cadmium Yellow Light.

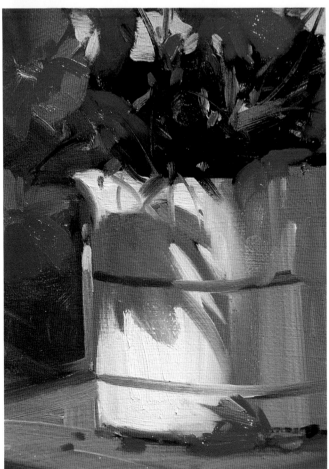

8 DETAIL: PASS THE COLOR AROUND

Add some fallen petals to the foreground, bringing the flower color to another area of the painting for more harmony and balance.

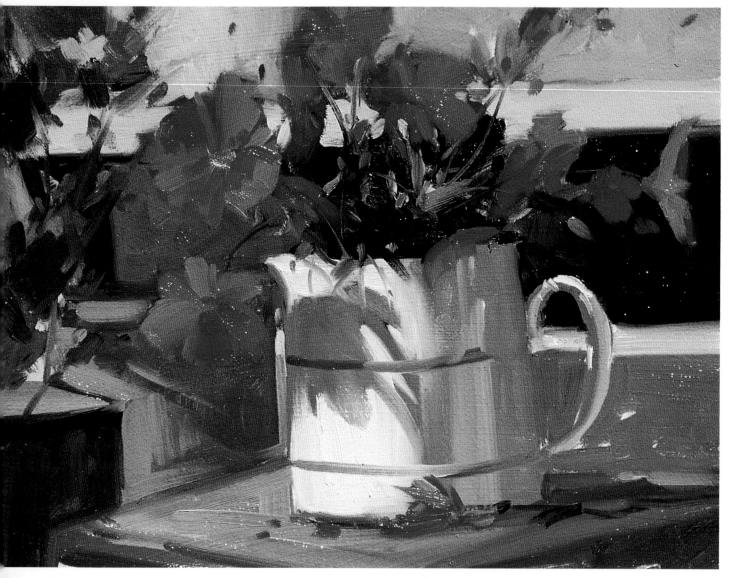

HOWARD CARR
Floral and Pot
Oils, 20"×16" (51cm×11cm)

9 APPLY FINAL TOUCHES

Add some foliage on the left to bring the viewer's eye back into the picture. To add more warm notes, place small orange accents to indicate the light hitting some small wildflowers with stems invisible in the shadow.

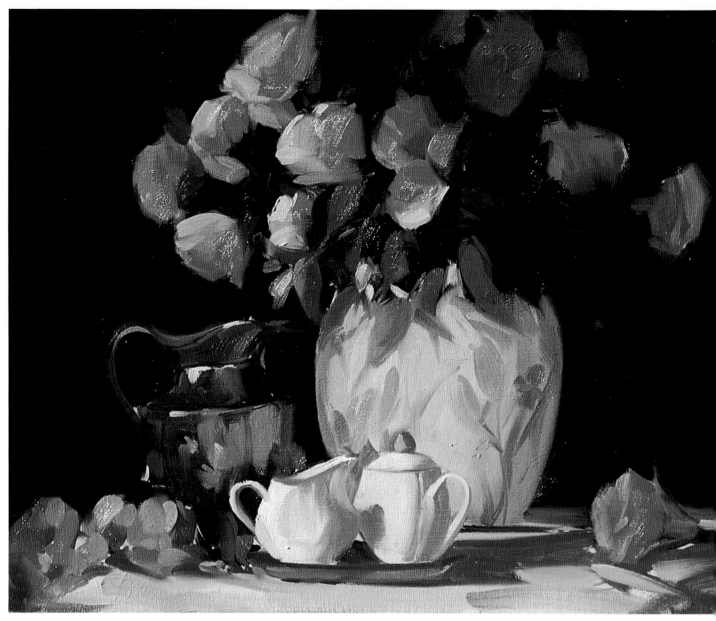

HOWARD CARR
Grandma's Antiques
Oils, 30"×24" (76cm×61cm)

A Tranquil Still Life

This flower still life is softer and more formal feeling, perhaps even a bit more delicate, than *Floral and Pot*. This, in part, is due to the use of more muted tones in the foreground to balance the richer colors elsewhere. Lots of warm neutrals lend an overall harmony to enhance the tranquil mood of the scene.

TIP Stay away from white to lighten bright colors, such as the flower colors in the above pitcher. Use lighter colors of the same family to lighten and you'll get richer results.

Paint Light–Filled Florals

DEMONSTRATION: WATERCOLOR

Dramatic Floral With Spotlight Effect

ANN PEMBER

In a spotlight effect, the bright light comes from one direction, usually from the front, off to one side. This creates a strong interplay of light and dark values throughout the composition, not just at the edges of a flower. It gives an opportunity to use the colors from their lightest to their most intense forms.

1 DRAW AND PAINT THE FIRST PETALS
Sketch just enough to guide you through the shapes. Don't get bogged down with too much detail. On the upper part of the flower, wet the top petals and float in Permanent Rose, Permanent Alizarin Crimson and Antwerp Blue, letting them mingle. Change color often, softening and blending the edges. As the paint begins to dry, add darks to form the ridges on the petals. Lift lights with a thirsty clean brush before the paint is fully dry.

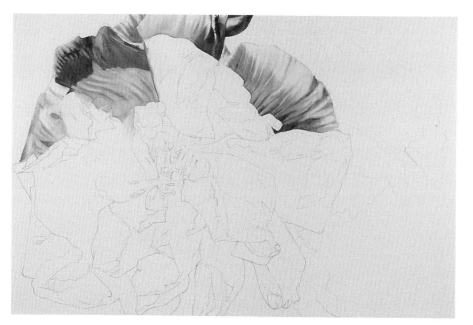

2 ADD SHADOWS
Wet the whole left side, carefully connecting shapes, and charge this area with rich amounts of Permanent Rose, Permanent Alizarin Crimson and Antwerp Blue. Make it dark, but keep the edges soft. Be sure to change colors, letting them mingle. Work quickly; keep it liquid.

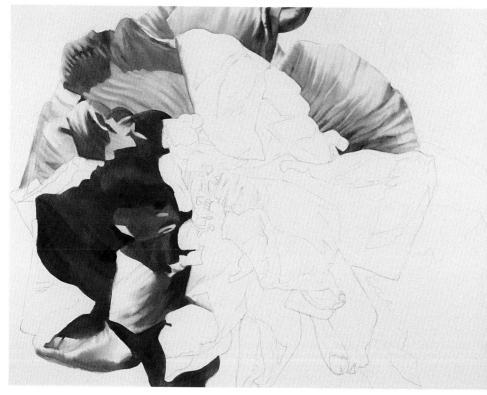

3 FILL AREAS AROUND SHADOWS

Wet and float in light strokes of Permanent Rose and Antwerp Blue to fill in petal areas to the left of and above the shadows you just painted. Wet the petal shape in the center top and float in Permanent Rose, Antwerp Blue and Permanent Alizarin Crimson. Add darks to give form and shadow when the paint reaches the damp stage, and pick out highlights with a clean, thirsty brush. Soften some edges, including the bottom.

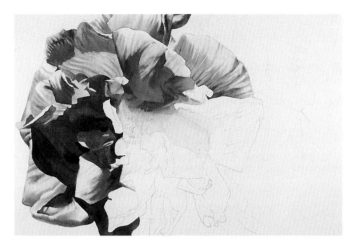

4 PAINT THE PETAL ON THE RIGHT SIDE

Wet the shape and float in the light tone using Permanent Rose, Antwerp Blue and Permanent Alizarin Crimson. When just damp, add more intense colors of the same hues to give form and show ridges, and also add Cadmium Red Purple. Soften the edges where desirable.

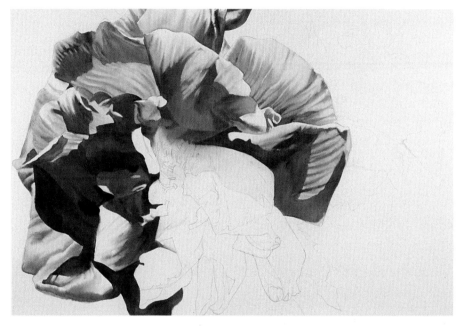

5 PAINT THE DARK CENTER

Carefully glaze over adjacent shapes and blend the edges, using Permanent Alizarin Crimson, New Gamboge, Cadmium Red Purple and Antwerp Blue in darker ranges. As the area dries, add the darkest darks. Blend the edges.

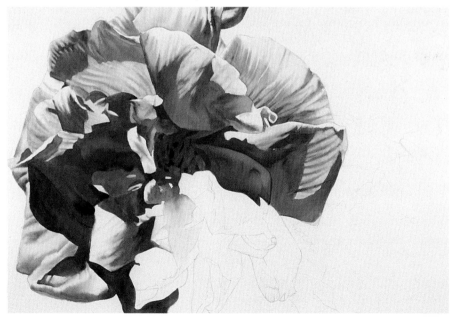

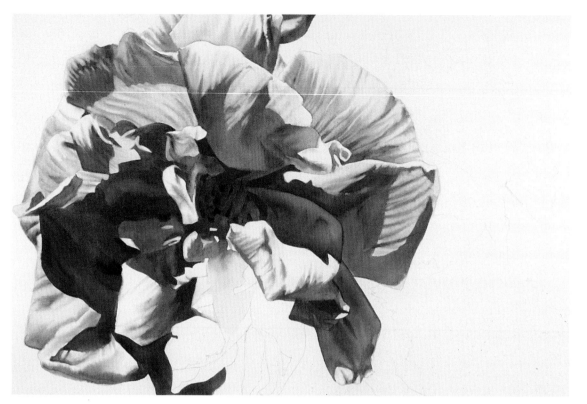

6 PAINT THE LOWER PETALS

Wet the shapes on the bottom right as one and charge with Permanent Alizarin Crimson, Permanent Rose, Cadmium Red Purple and Antwerp Blue. Clean up the edges; soften and pick out highlights.

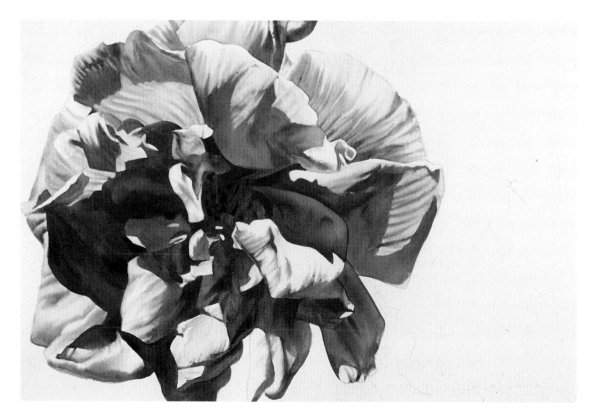

Add darks toward the end of the drying time for shadow, form and ridges. Handle the bottom petals the same way.

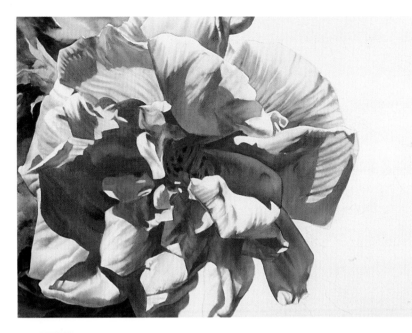

7 BEGIN THE BACKGROUND

Wet the upper left background area and charge with Permanent Rose, New Gamboge, Permanent Alizarin Crimson, Antwerp Blue, Winsor Green and Raw Umber. Paint around the bud. For the bud, wet and then mingle New Gamboge and Raw Umber on the leaves and Permanent Rose and Permanent Alizarin Crimson on the bud. Continue painting the background down the side to the bottom. Add the darks last, and use some Permanent Rose in the bottom areas.

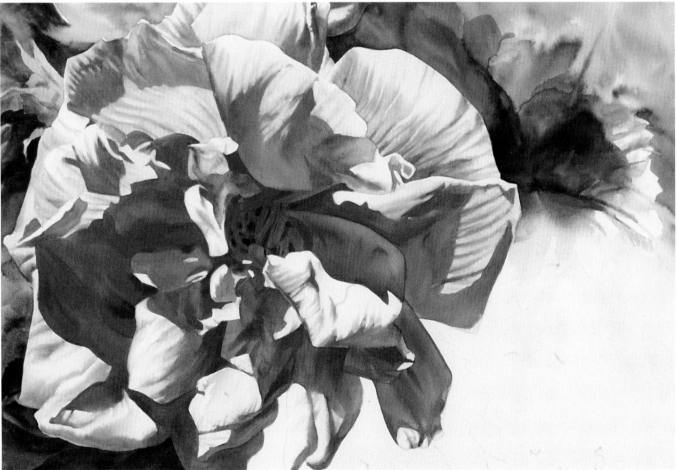

8 DEVELOP THE BACKGROUND

Wet the upper right background area and charge with rich amounts of Permanent Alizarin Crimson, Antwerp Blue, New Gamboge and Permanent Rose to suggest flowers behind the rose. Next to that, float in New Gamboge, Antwerp Blue, Permanent Rose and Winsor Green. Change colors often, soften the edges and keep things wet. As the area dries, add darks and pull out highlights.

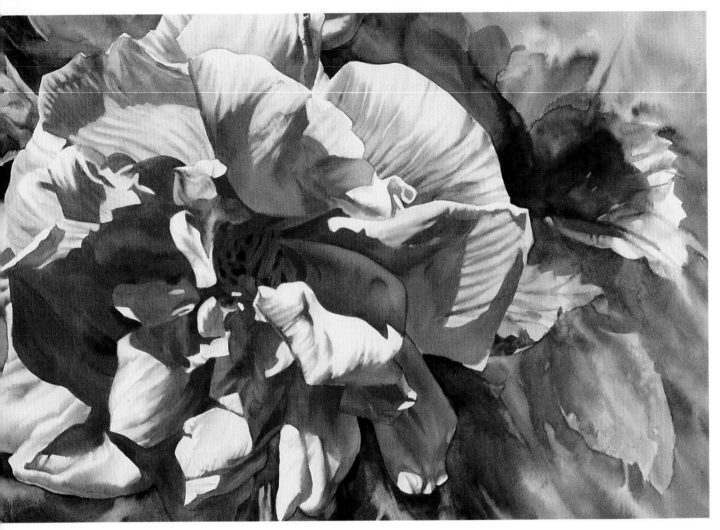

ANN PEMBER
Rose Glow
Watercolor, 15″×22″ (38cm×56cm)

9 REFINE AND FINISH

Wet the lower right background and float many color changes into the whole area. Use New Gamboge, Antwerp Blue, Permanent Rose, Raw Umber and Permanent Alizarin Crimson. Toward the end of the drying time, spritz with a spray bottle just a little to add texture. Let this dry. Add some darks under the flower. Add darks and some lavender in the upper left. Below the rose, remove some darks with a clean brush, then float in Antwerp Blue, Permanent Rose and New Gamboge. This area is too dense. Form another leaf at the right by glazing with the colors used in step seven, deepening the tone around the leaf to give it an interesting shape. Clean up the edges and lift, or lightly tone, a few lights. Add another glaze of purple under the new leaf and soften the edges. Know when to stop.

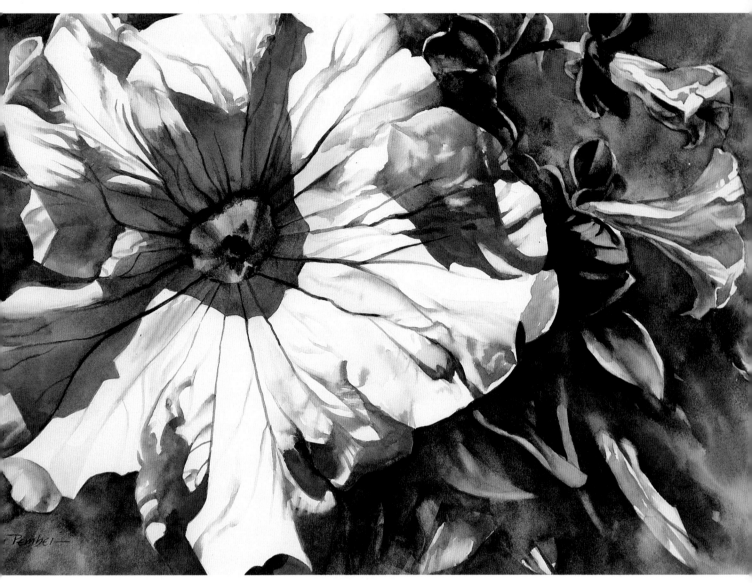

ANN PEMBER
White Petunia
Watercolor, 14" × 21" (36cm × 53cm)

Another Flower in the Spotlight

This painting shows the same type of dramatic lighting as *Rose Glow*: a spotlight effect. To be sure to keep the dramatic contrast of this effect, it helps, again, to simplify the complexity of your flower, connecting shapes where possible. Colors were floated into wet areas of the paper and allowed to mingle. The loose, out-of-focus background is quite dark in value, making the flower shapes stand out. Most details were added as the painting dried. In this case, some calligraphy was also added in the veins of the flower. Calligraphic touches such as these can give a loose painting welcome focus, if not overdone. Finely painted features must always be done on dry paper.

TIP Vary colors within a strong design by first bathing your flower subject in marvelous extremes of sunlight. Then, once you have lights and darks worked out on paper, link similar value shapes together, dropping in new colors with a wet-into-wet technique. This forms interesting colors and patterns through the painting and strengthens the painting's design.

Using a Palette Knife

MARILYN SIMANDLE & LEWIS BARRETT LEHRMAN

In the following pages, you'll see that a palette knife is a very important part of Simandle's work kit. Who says only oil painters get to use one?

Her preferred palette knife is long, with an angled end. The blade is small, narrow and very stiff. She keeps it handy as she paints, and while a particular color passage is still wet, she puts it into play. Here's how.

1 SCRATCHING

The rounded tip is perfect for scratching out tree branches, boat masts, mooring lines and such. If the wash is still moist, the scratch will be white. Where the wash is glistening wet, the paint will be drawn into the scratch and turn dark. You'll have to work quickly, before your wash dries. You can often re-wet a dried wash to scratch it.

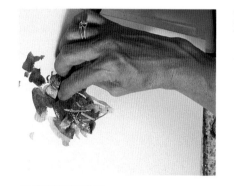

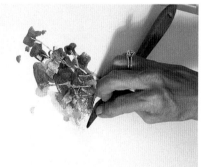

2 SQUEEGEEING

Hold the blade of the knife so a long edge is against the wash. Moving it as shown will squeegee most of the wet or moist color away.

3 SMEARING

Pressing the flat bottom of the knife blade against the wet wash, you can smear the moist paint to create texture.

4 APPLYING

You can also apply paint with your palette knife, just like an oil painter. Here is a gob of paint on the bottom of the palette knife, and here it is smeared directly onto the paper. Different results occur when the paper is wet, dry, painted or unpainted—often a great deal of accidental texture. Experiment with this technique, but don't try to control it too much.

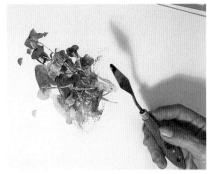
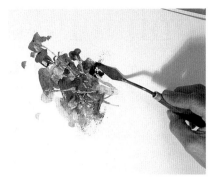

5 DRAGGING

If you tip the palette knife on edge and pull it in a slicing motion, you can drag out a narrow line of paint. This isn't easy to control, however, so be prepared for (and accepting of) surprises!

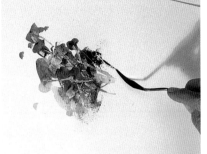
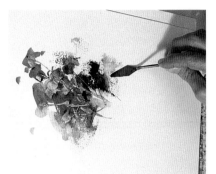

6 MOVING COLOR AROUND

You can dip your palette knife in water and use its flat bottom to move color around, especially if you have applied it as in the two preceding examples. Depending on paper surface, degree of wetness, and so on, you'll achieve interesting random effects this way. Again, it's not all that easy to control, so expect the unexpected.

Blooming With Light

MARILYN SIMANDLE &
LEWIS BARRETT LEHRMAN

Use your subject as reference only. Never just copy what you see. Here's the artist's floral setup. Wow! Busy, busy, busy! Everything hits the eye at once. Cropping the subject to eliminate the unnecessary is a good way to begin thinking about redesigning your subject; close one eye and look through a viewfinder, or frame (usually cardboard), to help focus your attention on a specific scene while blocking out all surrounding material. If you're working from a photo, you can crop it with four strips of paper, then clip or tape them in place. As you paint, simplify what's left by omitting things you don't need, such as the right edge of the table. The background carnations and foreground roses add nothing. Leave them out. The lilies are separated and pointing in every direction. Group them. As with any subject, you should plan on moving elements around to create a variety of sizes, shapes and color.

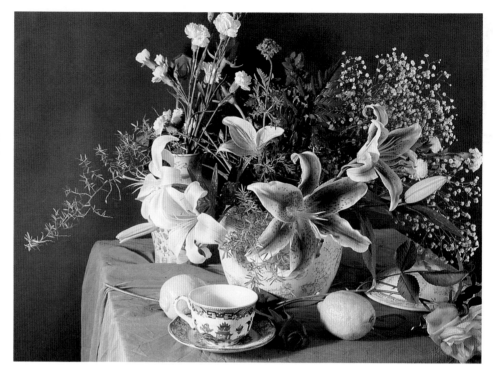

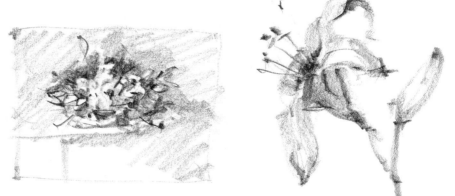

1 CREATE THUMBNAILS AND VALUE SKETCHES

The subject in the sketch at left is too small, too centered. If you're afraid to move in close, you often end up with a tiny subject floating in a large field, objects reduced to insignificant dots and the background dominating the composition. That just doesn't work. If you're going to extremes, it's better to move in really close, framing a single blossom (or even just part of a blossom to fill your paper). Develop your best idea with a slightly more detailed value sketch in just three values: light, medium, dark. Now you're ready for the big time.

Choosing a Composition

Thumbnail sketches help you decide how possible arrangements will fit on your paper. You get to know your subject better with each sketch. As you do your thumbnails, think of shapes and masses, not flowers. Try to create connected dark masses and connected light masses. Above all, keep your thumbnails simple!

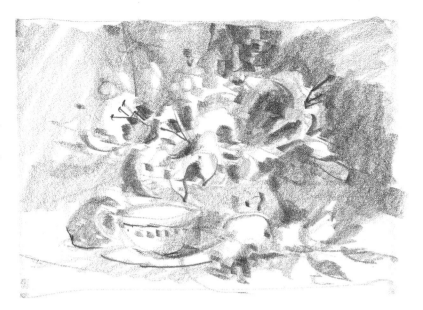

2 MOVE SKETCH TO WATERCOLOR PAPER

Lay out your plan with a full-sized drawing on watercolor paper. Go for the big shapes first—massing, overlapping and fine-tuning. Don't like the bowl? Change it. Would a second bowl hiding behind it bring the first bowl forward? Add it now. Would fallen leaves and stems add interest? Sketch them in.

3 PAINT LARGE MASSES FIRST

As with a landscape, get your largest mass down first. Here it's the background, a middle-value gray-green wash of Manganese Blue and Raw Sienna, with a touch of Permanent Rose. Paint negatively around the floral shapes, varying the hues with warm (Cadmium Orange, Raw Sienna) and cool (Manganese Blue, Permanent Rose) colors each time you recharge your brush. Scratch into each still-moist wash to create the tangle of stems and leaves characteristic of an informal flower arrangement. Repeat this scratching frequently as you progress.

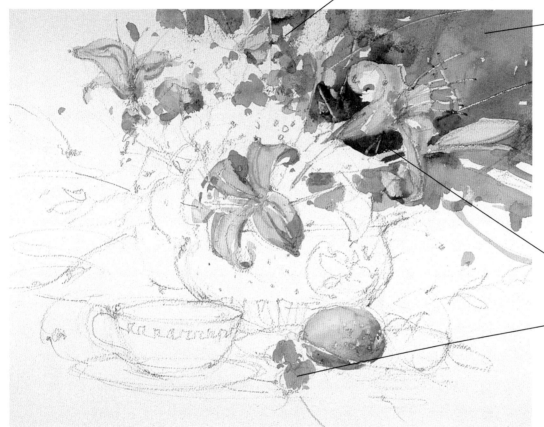

Leave plenty of whites for sparkle and light

Begin here with a middle-value gray-green wash of Manganese Blue and Raw Sienna, with a touch of Permanent Rose

Negative shapes help develop positive shapes

Soft violet (Permanent Rose and Manganese Blue) serves as a complementary contrast against the adjacent yellow of the lemon; move this violet around the painting

4 DETAIL: USE A VARIETY OF GREENS

It's time to start dealing with varied greens. To do that, start by eliminating all tubes of green paint from your palette. Using green straight from the tube makes all greens look alike. You can easily mix warm, cool, light, dark, bright and grayed greens with colors you already have on your palette; just vary the proportions of each pair of colors, or even add a third color, but avoid mixing more than three. Experiment by blending them wet-in-wet, and watch your washes come to life.

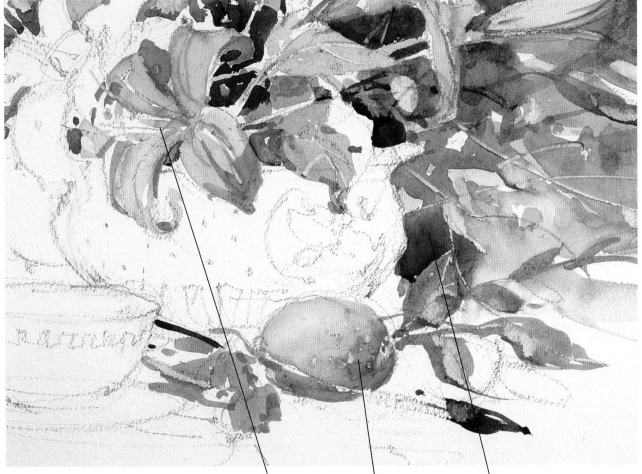

Begin local color of the point-of-interest flower with Permanent Rose and Cadmium Orange; when dry, shadow with both colors darkened with Burnt Sienna

Squeegee and move moist paint around with your palette knife; wash with Winsor Yellow, then drop in Cadmium Orange wet-in-wet

Shade with Burnt Sienna; make texture by stippling in tiny specks with your palette knife

5 FOCUS ON THE POINT OF INTEREST

Point of interest is also known as the subject of a painting where the viewer's eyes ultimately arrive. Everything else in the painting should emphasize this point.

Consider not only the shape you're painting, but also the shape you're leaving behind

Begin building darker values to frame the point of interest

Place leaves where you want them, not where they happen to be

Begin moving background down to meet foreground

A mixture of Cobalt Blue and Permanent Rose forms a darker, softer violet

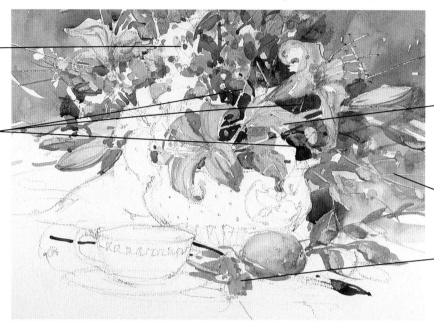

6 CONNECT SHAPES, DEFINE PATTERNS

Begin connecting masses to unify the composition, squinting frequently to view the painting in terms of large shapes and patterns.

A darker wash of Alizarin Crimson and Burnt Sienna yields rich accents

This lily is cooler and less bright because it's a secondary point of interest

This lemon is darker and not as bright because it isn't in the point of interest

Warm the shadowed gray wash with Cadmium Orange to suggest light reflected from the lemon

Glazing shadows over the china pattern softens its edges

Make the background wash warmer as you bring it forward

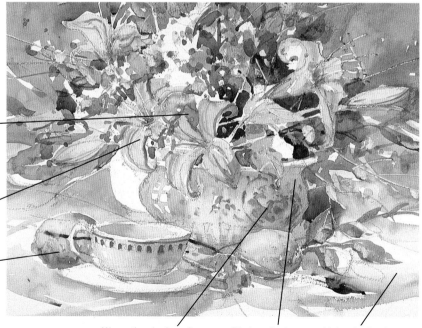

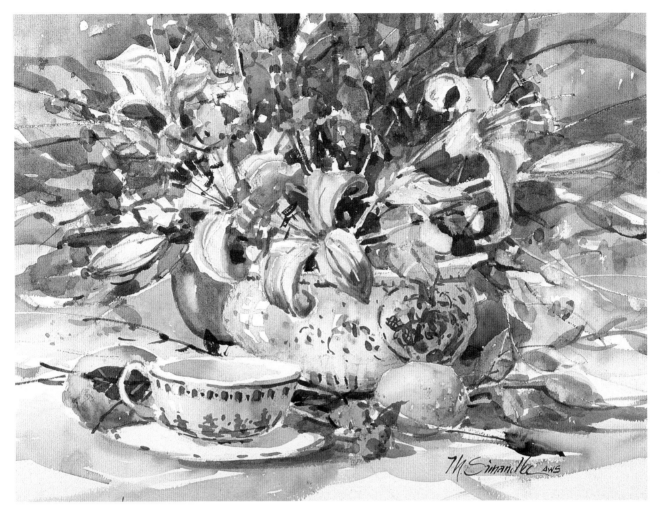

MARILYN SIMANDLE
Lilies, Lemons and Porcelain
Watercolor, 14" × 18" (36cm × 46cm)

7 ADD FINISHING DETAILS

Stand back and try to look at your painting objectively. Turn it upside down to see it soley as shapes and colors. Is it too busy? Glaze in color to tie fragmented areas together, as done here with the background at top center. Do too many elements stand out at once? Glaze some darker to push them back; brighten the point of interest by surrounding it with darker shadow masses. Are values running together? Perhaps you need to separate them with value changes. An additional element, like the leaf at lower left that separates the cup handle from the lemon, may be just what the piece needs. Add final details, such as the china pattern, dark linear stems and, of course, your signature.

Creating a Luminous Interior

MARILYN SIMANDLE & LEWIS BARRETT LEHRMAN

The limitations of the photographic process invariably cause shadows to appear dark, dense and lifeless. Compare almost any photo to the actual subject. You'll be amazed at how much the camera has lost!

Before you spend time painting from photos, absorb plenty of experience studying and painting the real thing. Only then will you know how to replace, recreate and reinvent what your photo reference will inevitably have lost.

Muddy Shadows

See how muddy the shadows appear in these two snapshots? The artist's memory of this room would tell her there was plenty of reflected light bouncing around when these photographs were taken. The shadows were filled with color and detail so let's find that light and bring it to life.

Sunlit flowers on the windowsill are a nice touch

There's lots of detail and color in these shadows, but the camera has lost them

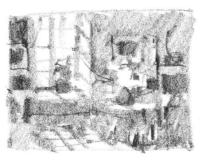

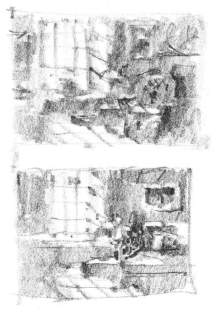

Let's work with the brilliance of these exciting light-and-shadow patterns

On the plus side, all the shadow shapes are nicely connected

You can hardly see the beautiful bouquet on the table

1 COMPOSE THE SUBJECT

Whether you're working from photos or sitting right there in the room, begin by editing what you see. Leave out what's irrelevant, distracting, confusing. Experimenting with plenty of thumbnail sketches will help you arrive at the best solution.

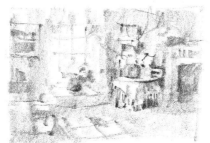

2 SEE SHADOW SHAPES AND PATTERNS

Once you have a plan that you think will work, try one or more value sketches to confirm your choice, using them to further develop composition, value patterns and details.

An important key to unifying your paintings is know how to use shadow shapes to connect the elements. When the major shapes in a painting exist as separate spots, unconnected and unrelated to each other, there is nothing to hold the composition together and everything falls apart.

Disconnected Shadow Shapes

In this sketch, the shadow shapes are not connected. There's no point of interest, nothing to hold the composition together and nothing to keep the viewer's eye in the painting.

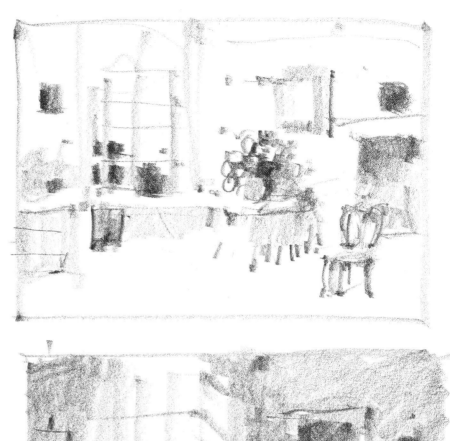

Nicely Connected Shadows

Here the light is centralized. Shadow shapes are large, varied and nicely connected. Now the eye moves easily from one element to the next. The composition is interesting. When you've developed the right approach to thumbnail sketches, they'll help you to see value patterns. Your thumbnails should not be outlines of objects or masses but roughly stated value patterns: light, mid-gray and dark.

3 TRANSFER THE CONCEPT TO WATERCOLOR PAPER

Sketch the largest, most important shapes first: the pattern of light in the window and on the floor, the table with its bouquet. Then develop the shadowed areas to left and right.

Begin here with Antwerp Blue and Permanent Rose with a touch of Cadmium Orange; keep it simple, light and colorful

Flow a little Manganese Blue into the wash

Wet-in-wet here yields the soft edges you want, outside of the point of interest

4 DETAIL: PAINT THE BIG SHAPES FIRST

It's fun to get right to the point of interest, but this time, start with the major shape at top right to establish the dominant shadow value. It will contrast nicely with the brightness and complexity of the floral arrangement. Remember to think shapes and colors, not objects.

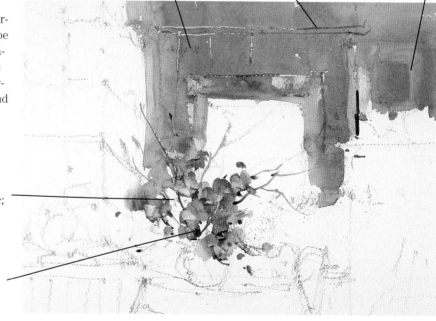

Leave plenty of whites within the floral arrangement for light and sparkle; vary shapes for interest

Build greens with mixture of Antwerp Blue, Burnt Sienna and Raw Sienna

Note how shapes are connected throughout the composition.

With a palette knife, scrape and smear the small secondary floral shape before it dries

These whites are very important

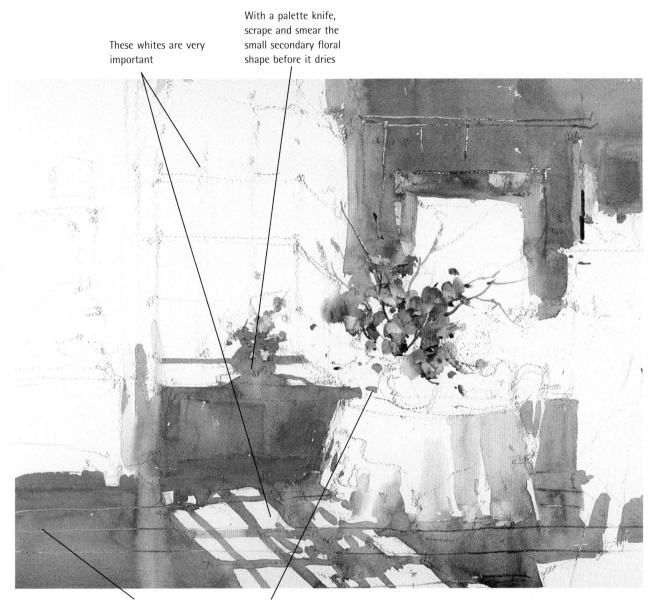

Use mixtures of Manganese Blue, Permanent Rose and Scarlet Vermilion for this warm foreground wash

Ending a wash with a few spots of color enables one's eye to move easily from place to place

5 COMPLETE THE FIRST WASHES

Begin glazing deeper, richer values into shadow washes. By now, you should be bringing most of your shadow areas to the desired values. Even at this early stage, keep in mind that both diversity (light against dark, textured against smooth, large masses against small) and harmony (pleasing color and value transitions, areas of sameness and rest) are needed to create visual appeal.

Narrow value ranges in shadow areas help focus attention toward the point of interest

Color changes in window mullions keep them interesting, emphasizing the dazzle of light

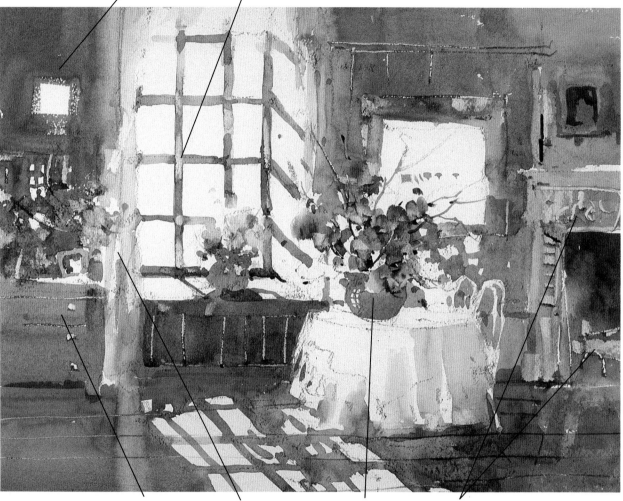

Mix Manganese Blue and Cadmium Orange for a cool green

Mix Cadmium Yellow and Cadmium Orange for sunlit draperies

Use Cobalt Blue in the pot, then spot it elsewhere in the painting as well

Scratch highlights with a palette knife into the still-moist wash

6 BUILD VALUE CONTRASTS

Value is the degree of lightness or darkness of a color. While light colors are considered to be high value, dark colors are thought of as low.

Contrast is the difference between elements. In this case, contrast between values would be black against white or dark colors against light colors. Now add contrast to your painting to create emphasis and added interest.

Continue to glaze texture and detail into the flowers

Here's an opportunity to put in a miniversion of one of your favorite paintings, but keep it subdued and simple

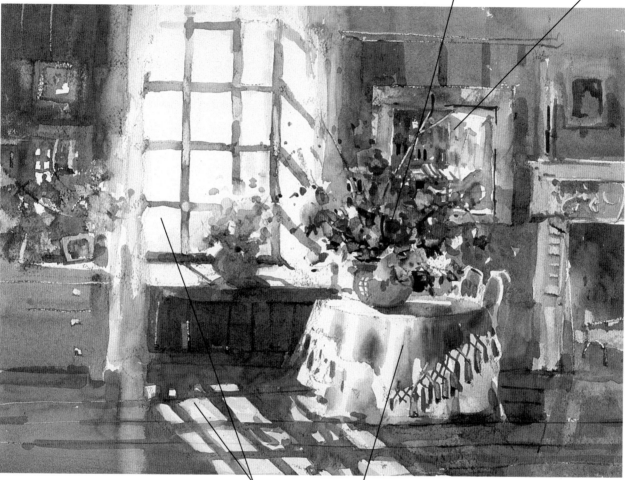

A few light touches of Cadmium Orange soften and warm sunlit surfaces

For the table cover, use Cadmium Red and Burnt Sienna—note how well this reads as a red tablecloth, even though color is visible only in shadows

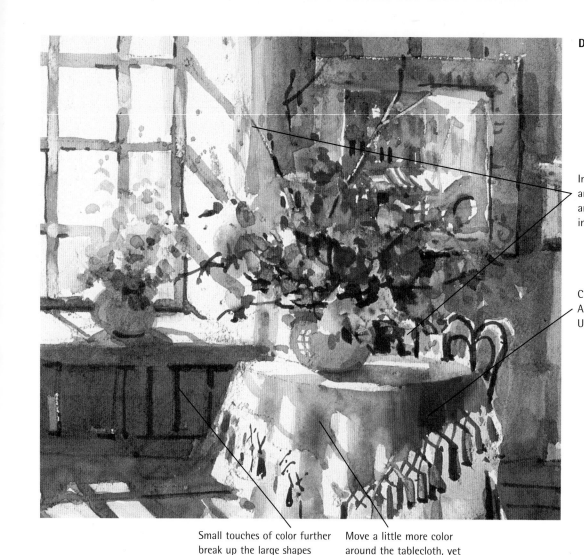

Intriguing color, linear details and touches of Cadmium Orange and Cadmium Yellow build interest

Create a deep shadow value with Alizarin Crimson and French Ultramarine Blue

Small touches of color further break up the large shapes

Move a little more color around the tablecloth, yet be aware of how little it really needs

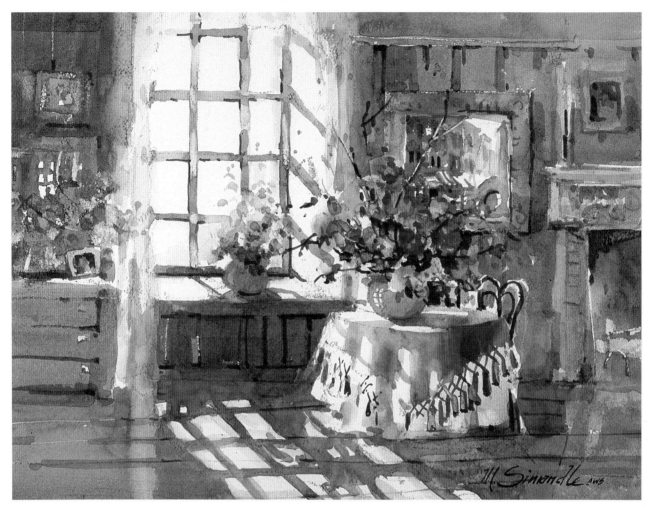

MARILYN SIMANDLE
Winter Sunlight
Watercolor, 12" × 16" (30cm × 41cm)

7 ADJUST VALUES, FINISH DETAILS

Were you to compare the finished painting with the snapshots on page 118, and had you not painted along, you might wonder how we got from there to here. How lifeless this painting would have looked had we simply copied those photos. The lesson is clear: Never rely on your photo resources for shadow detail or color. Use your memory or imagination to re-create them for paintings with glowing light, rich color and life.

Gallery

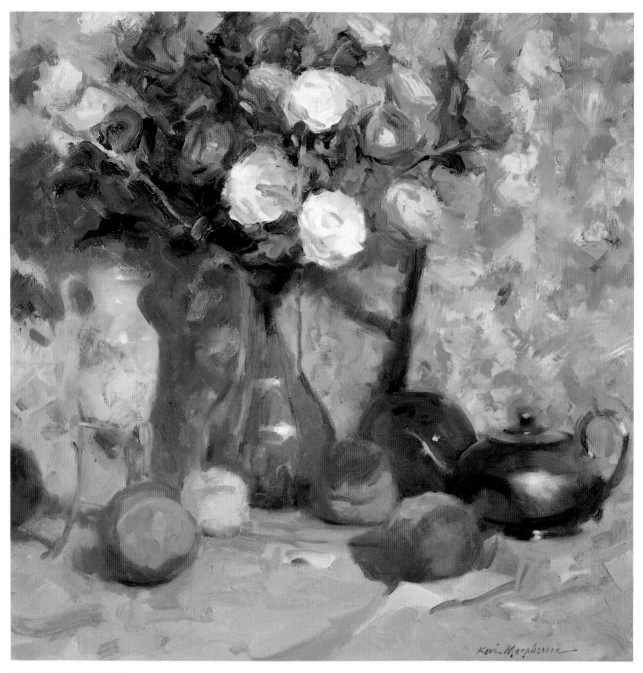

KEVIN D. MACPHERSON
Something Blue
Oils, 20″×20″ (51cm×51cm)

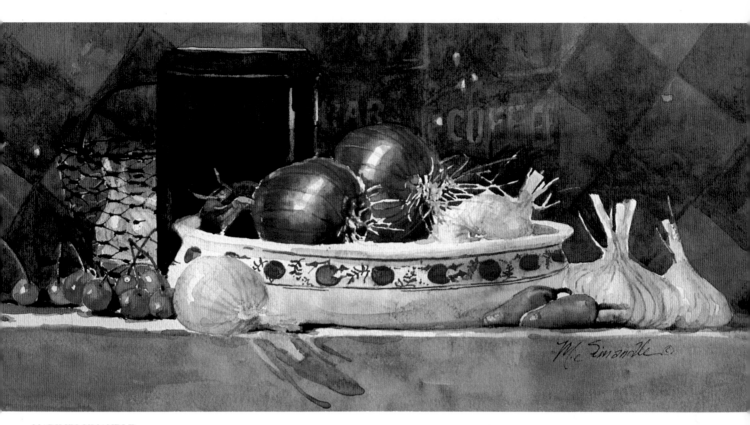

MARILYN SIMANDLE
Onions
Watercolor, 8"×16" (20cm×41cm)

GARY GREENE
Flower Power
Colored Pencil,
32"×40"
(81cm×102cm)

INDEX